Quilt Blocks Across America

DEBRA GABEL

Text and Illustrations copyright © 2010 by Debra Gabel

Photography copyright © 2010 C&T Publishing, Inc.

Publisher: Amy Marson

Creative Director: Gailen Runge

Acquisitions Editor: Susanne Woods

Editor: Gailen Runge

Copyeditor/Proofreader: Wordfirm Inc.

Cover/Book Designer: Kerry Graham

Production Coordinators: Jenny Leicester and Zinnia Heinzmann

Production Editor: Alice Mace Nakanishi

Photography by Christina Carty-Francis and Diane Pedersen of C&T Publishing, Inc., unless otherwise noted

Published by C&T Publishing, Inc., P.O. Box 1456, Lafayette, CA 94549

All rights reserved. No part of this work covered by the copyright hereon may be used in any form or reproduced by any means—graphic, electronic, or mechanical, including photocopying, recording, taping, or information storage and retrieval systems—without written permission from the publisher. The copyrights on individual artworks are retained by the artists as noted in *Quilt Blocks Across America*. These designs may be used to make items only for personal use or donation to nonprofit groups for sale. Each piece of finished merchandise for sale must carry a conspicuous label with the following information: Designs copyright © 2010 by Debra Gabel from the book *Quilt Blocks Across America* from C&T Publishing, Inc.

Attention Copy Shops: Please note the following exception—publisher and author give permission to photocopy pages 18–70 for personal use only.

Attention Teachers: C&T Publishing, Inc., encourages you to use this book as a text for teaching. Contact us at 800-284-1114 or www.ctpub.com for lesson plans and information about the C&T Creative Troupe.

We take great care to ensure that the information included in our products is accurate and presented in good faith, but no warranty is provided nor are results guaranteed. Having no control over the choices of materials or procedures used, neither the author nor C&T Publishing, Inc., shall have any liability to any person or entity with respect to any loss or damage caused directly or indirectly by the information contained in this book. For your convenience, we post an up-to-date listing of corrections on our website (www.ctpub.com). If a correction is not already noted, please contact our customer service department at ctinfo@ctpub.com or at P.O. Box 1456, Lafayette, CA 94549.

Trademark (™) and registered trademark (®) names are used throughout this book. Rather than use the symbols with every occurrence of a trademark or registered trademark name, we are using the names only in the editorial fashion and to the benefit of the owner, with no intention of infringement.

CityStamp™, GetAwayStamp™, StateStamp™, and NationStamp™ are trademarks of Debra Gabel / Zebra Patterns.

Library of Congress Cataloging-in-Publication Data

Gabel, Debra, 1961-

 Quilt blocks across America : appliqué patterns for 50 states & Washington, DC : mix & match to create lasting memories / Debra Gabel.

 p. cm.

 ISBN 978-1-60705-349-1 (softcover)

 1. Appliqué--Patterns. 2. Quilting--Patterns. 3. United States--In art. I. Title.

 TT779.G32 2010

 746.44′5--dc22

 2010024419

10 9 8 7 6 5 4 3 2 1

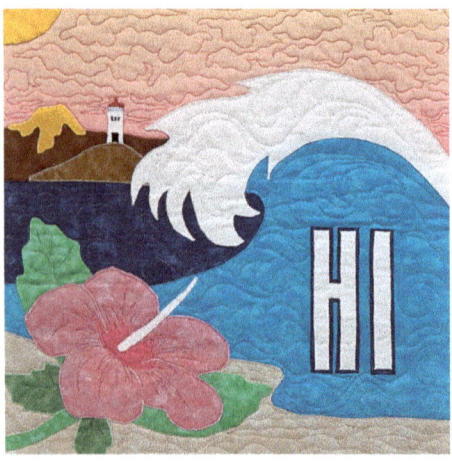

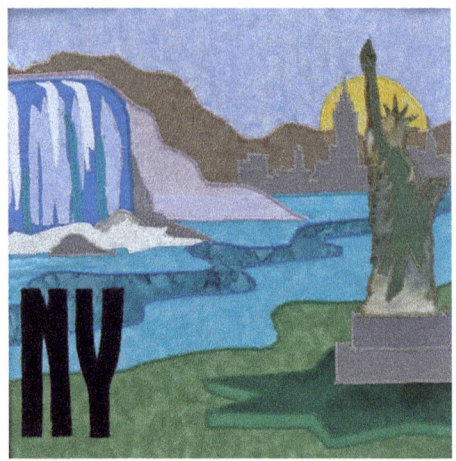

Dedication

I would like to dedicate this to my husband, Gary. Gary is, and always has been, supportive of me and my art and business ventures. He is the father of our three boys, Brooks, Austin, and Cole; my business mentor; my creative sounding board; my webmaster; my life and business partner. He was by my side in 2003 when I was diagnosed with and treated for the better part of a year—through chemotherapy and a stem cell bone marrow transplant—for non-Hodgkin's lymphoma. Gary, this one is for you. I hope we get to travel together and see every state in this book and more. I love you forever. Thank you for everything you do every day to support and guide our family.

Acknowledgments

This first book has been a dream of mine for many years. I would like to thank C&T Publishing, and especially Susanne Woods, Kerry Graham, Jenny Leicester, Zinnia Heinzmann, Alice Mace Nakanishi, and Gailen Runge, for being so kind and professional in providing this opportunity. The writing and production were painless with C&T's help.

My boys—sons Brooks, Austin, and Cole, along with husband, Gary—were my personal creative focus group. I would design a state block, and they would all have to give their okay on the design before I moved to the next pattern.

Jackie Bingham and Carolyn Adams, of the inspiring Patches Quilting & Sewing in Mt. Airy, Maryland, have provided encouragement and support since the founding of Zebra Patterns.

Fellow guild members at Faithful Circle Quilting Guild and Milltown Quilters of Columbia, Maryland, and Nimble Fingers of Bethesda, Maryland, are always generous with thoughtful feedback to new patterns and ideas. I will never forget that the very first CityStamp, Baltimore, evolved from a guild challenge and fellow members' requests—Glenda Kruger's, in particular—for a pattern after seeing the submission.

The Where Ya' Been? online volunteer group, many of whom I have never met, has been exceptional with samples, pattern testing, editing of instructions, and input. Patti Rusk must be singled out for help above and beyond the call of duty. I am very excited that volunteers' samples appear in the Gallery (pages 71–77).

Lastly, I would like to thank all the guilds that have invited me to lecture and lead workshops.

You are all part of the success of these patterns, and you all played a critical role in helping me zero in on a book that you wanted—and that C&T Publishing would bring to market. Everyone's kindness and positive energy are sincerely appreciated.

Contents

Preface...... 5

How to Use This Book...... 7

General Block Directions...... 11

Supplies...... 15

Patterns...... 17

 State Patterns... 18

 Alphabet Patterns... 69

 Mount Rushmore and Route 66 Patterns... 70

Gallery...... 71

Supplies and Resources...... 78

Glossary of Terms...... 78

About the Author...... 79

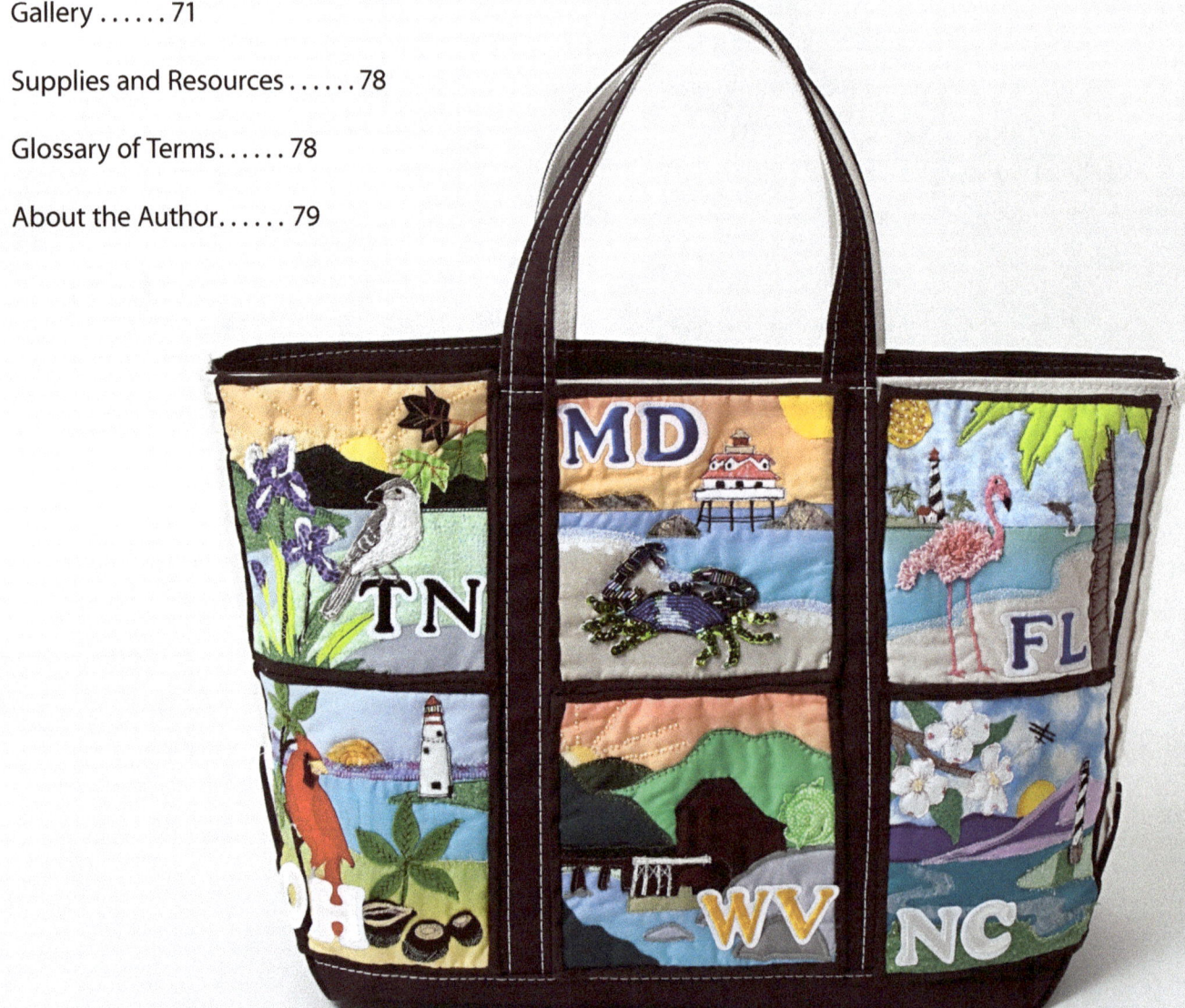

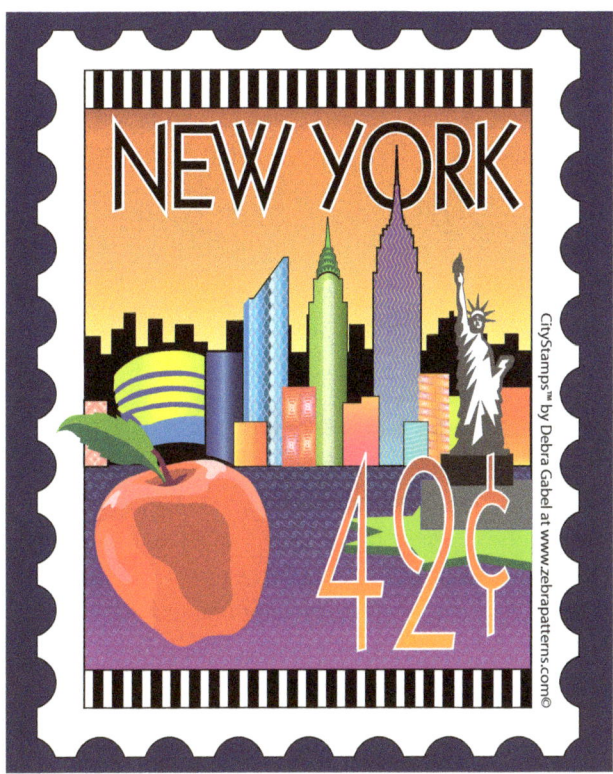
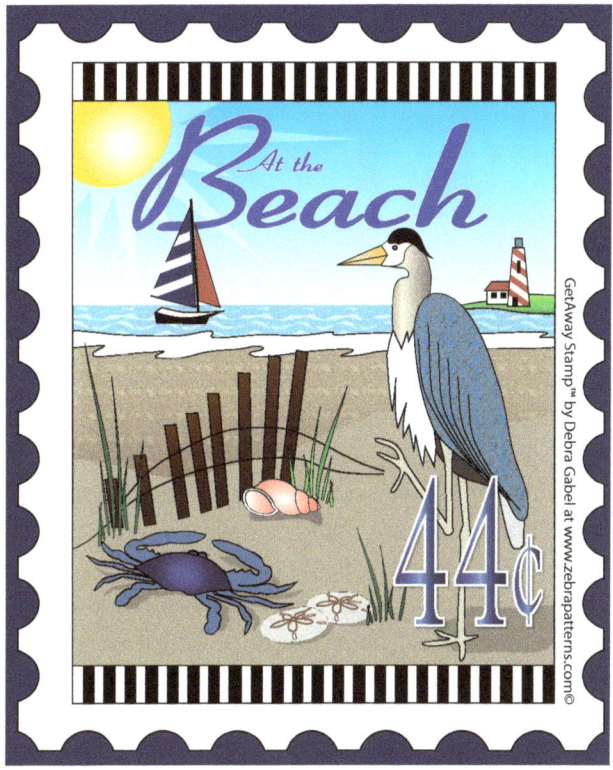

Preface

This is a book of firsts. It is my first book! It is the first time I have made such a large collection of patterns on one subject. It is the first time I have written a preface, acknowledgments, and glossary. It is the first time I have put my detailed raw-edge appliqué techniques and tips in writing.

As the designer of more than 100 commercial patterns under our Zebra Patterns brand, I have always wanted to create a book, but not just any book. There are thousands of quilting books out on the market. My first had to be unique in meaning and presentation. The objective of this book is to provide a comprehensive collection of image blocks for each state in the United States and the District of Columbia, as well as to serve as a library of designs. My style is not abstract or whimsical; rather, it is "quilting representational." This means that I try to capture subjects in a realistic way. I put on my quilting hat and ask myself how each design will transfer to cloth.

Pittsburgh's Spring 2009 International Quilt Market was our initial effort for launching the Zebra Patterns line nationally. The patterns were well received by quilt shops, book and magazine publishers, and fabric companies, with particular attention to the CityStamps, StateStamps, and GetAwayStamps. My stamp patterns are unique renditions of extra-large postage stamps that were totally concocted in my head. They are not real stamps—the answer to an often-asked question. They finish at approximately 24″ × 30″ and feature a composite pictorial landscape of a particular city, state, or place, all set in the likeness of a large postage stamp.

From the first day of Spring Market, it was clear that the stamps were hot. I went to Pittsburgh with eight stamps. Most show visitors asked, "When will you be doing my city/state?" It was clear that the audience was very invested in where they live, where they've traveled, where their family and friends live, and so forth.

Scottie travel trailer

Kentucky decal

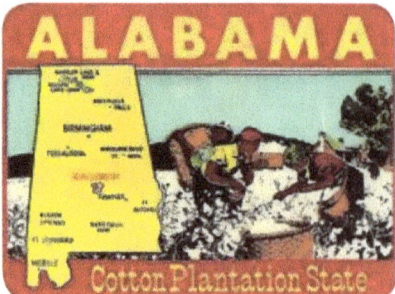
Alabama decal

After Pittsburgh I got to work creating more stamp patterns, challenging myself to develop methods to more quickly meet this demand. When creating patterns, I found that the actual designs came to me relatively quickly, as compared with the tasks of drawing pattern pieces and writing directions. When we left for the Fall 2009 International Quilt Market and Festival events in Houston, the stamps line had increased to twelve patterns and NationStamps and had broadened to include preprinted panels for each design. Nevertheless, the first question was, "Where is my city/state/country/special place?" Four patterns in four months was the fastest I'd ever brought new stamps to market, but we were still not meeting the demand fast enough.

Having three teenage boys, I am in the van a good amount of each day. The van is my think tank. The trips to basketball, lacrosse, soccer, and swimming were put to use thinking, "How can I go to the 2010 Houston Fall Market and satisfy customers in all 50 states plus Washington, D.C.? Is there a way to design all the states without having to draw pattern pieces, write custom directions, make samples, and produce pattern inventory for each design?" That is when "book" popped into my head. This was the perfect time to write my first pattern book.

The design process got underway immediately. Knowing that a book with 51 designs and patterns would require a huge number of pages, I developed what, to the best of my knowledge, is a unique method, using a translucent pattern representation so the quilter can trace each piece *and* see color, positioning, and overlap all in one block. Imagine looking down through the roof of a building with X-ray vision, and you will get the idea.

The printed pages and inspiration in your hands right now are the solution, allowing Zebra Patterns to make all 50 states and Washington, D.C., available at once. The reduced page count made possible by Translucent Patterning—a process Zebra Patterns will seek to patent—also made full-color printing possible, thanks to C&T Publishing. It is very satisfying to have this first book's topic and content be a direct response to my customer's requests. We have also included a comprehensive CD with patterns that can be enlarged and printed for ease of use.

After designing the first ten to twelve blocks, a fond childhood memory emerged. When I was a little girl, my family explored our wonderful country in a Scottie travel trailer. It was a small tow-behind with a double bed for my parents and a cool bunk bed for me in the rear. Every time we entered a new state, it was a family ritual to get a state decal for the windows of our trailer from the roadside Welcome Center. I now realize that through this book, I relived the experience of collecting decals for that trailer's windows, visualizing memorable times on the road with my parents. It is my sincere hope that from among the 51 designs in this book, you will find the blocks most meaningful to you—and to the recipients of your quilts—that will help answer the question *Where Ya' Been?*

How to Use This Book

Quilt Blocks Across America presents primarily raw-edge fused appliqué patterns with general directions for use, plus several tips and suggestions. You will find 51 patterns, one for each state and our nation's capital, Washington, D.C. The page layouts are consistent throughout. The states are listed alphabetically. The patterns are all designed as 6˝ finished blocks, but *I strongly suggest that you consider enlarging the designs for ease of use.* The larger the block size, the bigger the small pieces will be. You may hand turn the designs if you are a hand turner. You can enlarge designs by using the included CD or by making an enlarged color copy at any office products retailer or copy shop, or even at a growing number of public libraries. Keep in mind that you can enlarge the designs onto two pages and tape them together should you want a larger width than the standard 8½˝ × 11˝ sheet of paper.

I strongly suggest that you consider enlarging the designs for ease of use.

Descriptive and Directions Paragraphs

Each state page starts with a brief descriptive paragraph, making reference to notable facts and images in the pattern. The next paragraph gives simple general instructions, followed by creative suggestions, if applicable, to enhance that particular state block. If the simple directions on each pattern page are not informative enough for you, please read the entire General Block Directions chapter (pages 11–13), which covers how to assemble each block. By following the block directions and using the creative suggestions, you will be able to make a beautiful state block for your personalized quilt or project. You can always write to me at debra@zebrapatterns.com with any questions.

Read each block's directions paragraph carefully. Each paragraph starts with general piecing and fusing instructions, followed by embellishment suggestions or alternative ways to create some of the details, when applicable.

About Each State Design: Mix and Match

Many states have such diverse landscapes that it would be impossible to represent every landmark and geographic feature in one finished 6˝ × 6˝ square. I tried to pick out some of the more unique and distinguishable landmarks and geographic regions to be represented in a given state.

You will notice several lighthouses throughout. That was not by accident. Many quilters love the coastlines, lakes, and waterways of the United States and are drawn to lighthouses. When showing my guild some early sketches, I had comments, for example, about Ohio: "The Ohio I grew up in was all farmland. What's with that lighthouse?"

The Ohio I designed for this book is of Lake Erie, a buckeye, and the state bird. My reasoning was that Ohio is one of those diverse states that has many lakes and rivers, as well as major cities and farming. I felt that being located on Lake Erie was significant and that lighthouses—such as Marblehead—on the Great Lakes are notable and unique. See Ohio (page 53) for visual reference.

My suggestion to this quilter was to go through the book and find another state that features its agricultural setting and then make that *her Ohio*. (See Nebraska on page 45 and Wisconsin on page 67 for visual reference.) This is my suggestion to *you* as well. If your chosen state design is not the feel of your vision of the state, go through this book and find alternative graphics that *do* create the right feel. Mix and match!

Feel free to mix and match graphics from other states to make your block ring more true to your vision of *Where Ya' Been?*

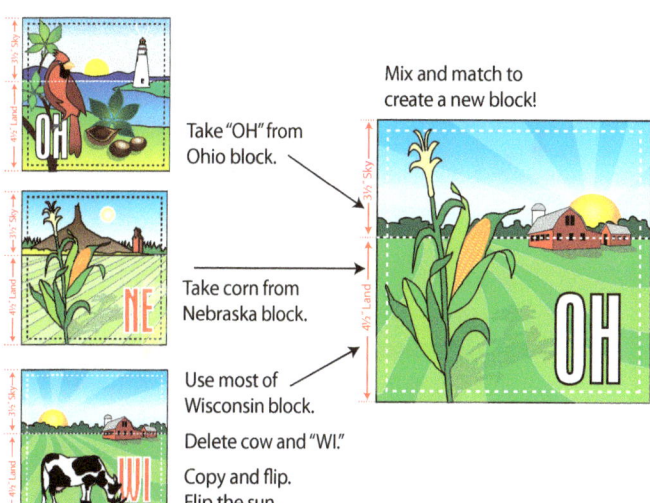

Creating Block Backgrounds for All Blocks

Throughout this book, all of the 6½˝ × 6½˝ unfinished patterns will have a 3½˝ × 6¾˝ sky (or land) piece sewn to a 4½˝ × 6¾˝ land (or sky) piece to make up the background of each block. The unfinished block should be 7½˝ tall × 6¾˝ wide; the extra background will allow you to position the seamline and trim the block to exactly 6½˝ square. The seam between the land and sky needs to be a standard ¼˝, pressed toward the darker fabric. You will place your fused appliqué pieces on this pieced background to complete the block.

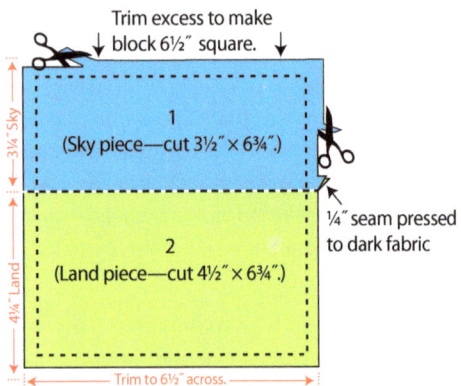

Numbering of Pattern Pieces

The sky and land pattern pieces are always numbered as 1 and 2. The remaining elements are numbered in the order they are to be assembled. Piece 3 will be positioned after the background is created, unless otherwise noted, and will then be followed by pieces 4, 5, and so on.

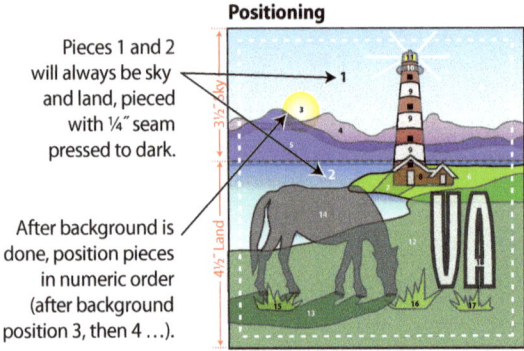

PATTERN PIECES WITHOUT NUMBERS

Some of the smallest details, such as windows and doors, may not have numbers. This indicates that the pieces would be better translated via thread or fabric paint. Some of these details can even be eliminated if you feel they are just too small. These small objects become more manageable after enlarging the pattern. By enlarging the 6˝ block 200%, a tiny ¼˝ window becomes a more manageable ½˝ piece.

Pieces without numbers

Tiny details of flowers and windows may not be numbered. Unnumbered pieces are best translated by using fabric paint or embroidery.

Translucent Patterning and Tracing

All of the patterns have been drawn with translucent overlapping color in order to show how the patterns fit together. Look carefully at each piece and then trace the outline of each numbered piece. The translucency allows you to see the overlap of each drawn piece. *Do not use each pattern's colors for fabric choices.* Refer to the small graphic drawing adjacent to the state paragraphs and block directions at the top of each state page for color recommendations. You will be tracing each numbered element separately onto tracing paper.

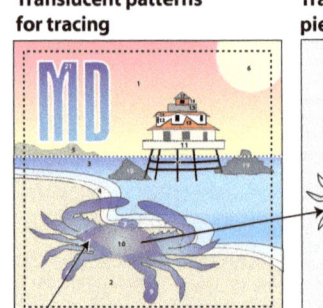 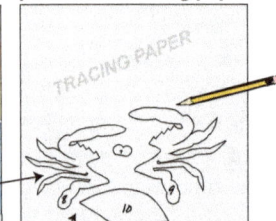

Translucent patterns for tracing
Pieces are translucent for tracing each overlapping appliqué piece. *Do not use* for color reference.

Trace and number pattern pieces onto tracing paper.
Trace each element onto tracing paper and write number on traced piece.

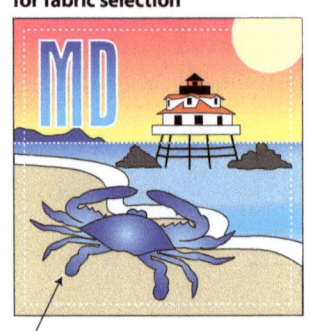

100% color patterns for fabric selection
Smaller illustration adjacent to written paragraphs on each page is 100% color for fabric choices.

Special Pattern Elements

Complete images of Mount Rushmore for South Dakota and Route 66 for Oklahoma are at the end of the pattern section (page 70). These elements are included separately because they are intricate and would be difficult to trace. Their historical significance is so meaningful that they should appear in cloth as accurately as possible. Mount Rushmore is in one piece on the top of the page and can be copied or scanned and then imaged onto printable fabric. The Route 66 sign is also prepared for imaging onto printable fabric. If you do not want to copy the images to printable fabric, you can use the pattern pieces and assemble as you would for any other element in the book.

Alphabet

When I was writing and designing *Quilt Blocks Across America,* I had many requests to provide an alphabet in its entirety for all the states. This alphabet appears at the end of the pattern section (page 69). The letters in the state abbreviations are made of two layers, with the lower layer creating an outline around the letter. Before I trace or cut the patterns, I adhere fusible web to the back of both letter fabrics. Then I trace the inner letter pattern on the chosen fused fabric. Next, I cut out the inner letter and fuse that inner letter onto the letter outline fabric. Last, I cut out the completed letter ⅛˝ away from the inner letter, which creates a narrow edge of outline fabric that peeks out from behind the inner letter. I find this process easier than cutting out each letter (inner and outer) and trying to line up the two fabrics.

Tips

Tip 1: If you have an embroidery unit on your sewing machine, you could embroider the letters using a similar font found in your software, or you could embroider the whole state name in a smaller font.

Tip 2: Purchasing and positioning iron-on alphabet patches from your local craft store is another way to achieve the type on each state block.

Tip 3: Creating your own two-color type on a computer and outputting to printable fabric is yet another way to achieve the type on each state block.

Raw-Edge Sewing

Sewing the raw edges is both a functional and an aesthetic task. Functionally, stitching down the raw edges holds the pieces in place and minimizes edge fraying. Aesthetically, sewing down the raw edges is an opportunity to add another design element with color or stitch choice. Raw-edge sewing is totally subjective. If you want the edging to blend, use matching-color threads. If an added noticeable line is desired, use a contrasting thread. The length and width of your zigzag stitching are also subjective. I use a somewhat narrow, tight zigzag, which I often describe as a dense zigzag or an open satin stitch. You can also use a decorative or blanket stitch to hold your edges down. Again, it is all subjective.

Anchor the first few stitches by sewing in place three times with the sewing machine. Then the zigzagging begins. When sewing the zigzag edging, it is important to position the stitching so that the outermost part of the stitch just pierces the underlying fabric. The main "bite" of the stitch stays on your cut pattern piece. If you straddle the pattern piece edge, you will see the zigging edges in your underlying fabric. If you miss the edge and zig only on the pattern piece, you will leave a sliver of unfinished fabric edging that will be prone to fraying. Try to pierce just outside the pattern piece edge. At the end of the zigzag stitching, I again anchor the stitches by sewing three times in place with the sewing machine.

Raw-edge stitching

Anchor stitches by sewing in place 3 times.

Pattern piece

Use matching thread and pierce edge of underlying fabric.

Underlying fabric

RAW-EDGE ZIGZAG CORNERS, POINTS, AND CURVES

Outer corners: When sewing raw-edge outer corners, zigzag to the corner edges. Stop sewing when the needle is in the down position and is stopped on the pattern piece's outer edge. Then pivot the work. Begin sewing again, crossing the first stitches. You might need to hand turn the sewing machine wheel and slightly adjust the fabric to get the needle in the right position so it pivots in the corner.

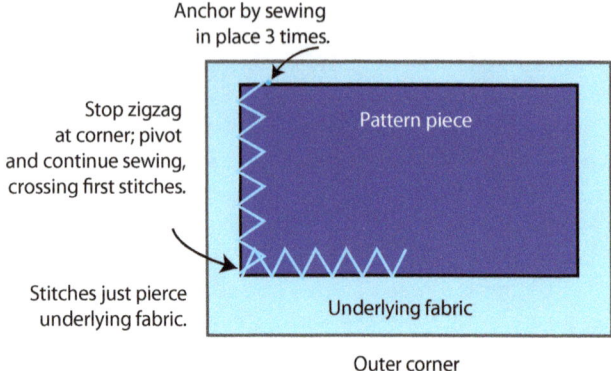

Outer corner

Inner corners: When sewing raw-edge inner corners, zigzag to the inner corner. Stop sewing when the needle is in the down position and is stopped on the pattern piece's outer edge. Then pivot the work. Begin sewing again. There will not be any stitches in the inner corner area.

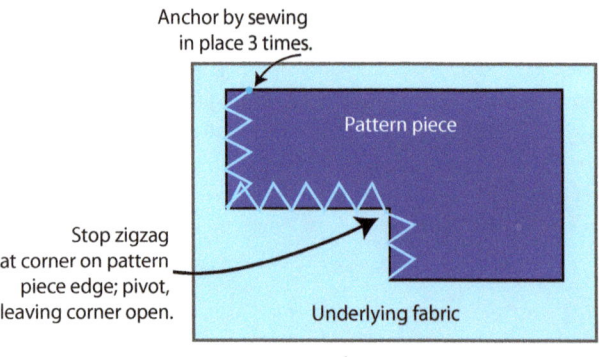

Inner corner

Curves: When sewing raw-edge curves, going slowly is critical. Sew one or two stitches, stop with the needle down, and then pivot. The number of stitches and the degree of pivoting depend on the tightness and size of the curve. The goal is to keep the zigzag stitches even throughout the curve.

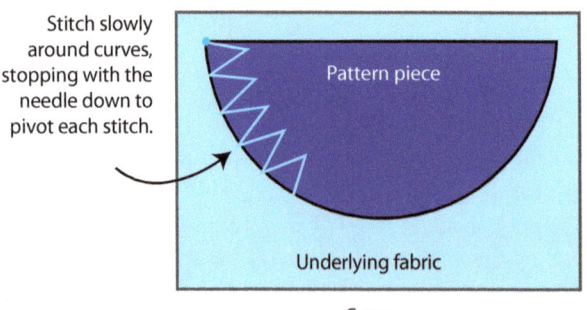

Curve

Points: When sewing raw-edge points, it is necessary to decrease the stitch width as the sewing machine advances down the point. End at the point with the needle down, and then reverse the stitch by slowly increasing the stitch width until the stitch is back to the original width.

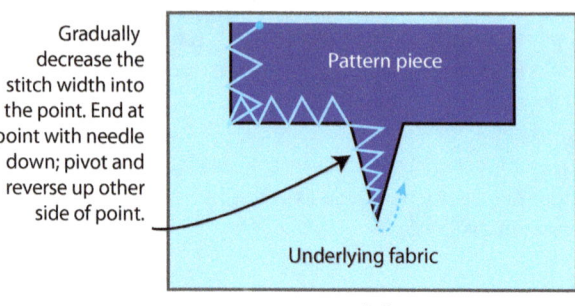

Point

Using Organza or Tulle for Shadows, Sunrays, or Clouds

Some of the patterns in this book have shadows or sunrays, while others have clouds. Most times, these items are not numbered, because they are optional. Using white organza or tulle for the clouds or sunrays will produce a light, translucent effect. Using black organza or tulle for shadows generally works well.

When working with organza or tulle, proceed in the same manner as you would for creating fabric pattern pieces. Mistyfuse Ultraviolet fusible is excellent for the fusible backing. It is very light and will maintain the sheer fabric's translucent properties. The ultraviolet variety protects the pieces from discoloring over time.

Organza and tulle are sheer, open-woven fiber products. When you apply fusible webbing to the back, it will bleed through to some extent. This makes using a nonstick pressing sheet essential. I prefer Bear Thread Designs' Appliqué Pressing Sheet.

I have found that high iron temperatures can melt or scorch organza and tulle more quickly than other fabrics. Determine and then use the lowest iron setting necessary to fuse. Once these translucent pieces are in place, always use a pressing sheet if further ironing is needed; this will avoid melting or scorching these fabrics.

General Block Directions

Materials Needed

Fabrics chosen for particular block

Fusible webbing

Mistyfuse (for basting)

Nonstick appliqué pressing sheet (2, or 1 large sheet that can be folded)

Sharp pair of cutting scissors

Rotary cutter

Quilting ruler

Good, clean iron

Access to a copy machine

Tracing pad and pencil

Lightbox (helpful for tracing, but not necessary)

Sewing machine with open-toe foot

Matching threads for all elements

Tear-away stabilizer for appliqué sewing

Batting

Clean workspace

Block Directions

1. Create the block background.

Cut a 3½″ × 6¾″ sky (or land) piece and a 4½″ × 6¾″ land (or sky) piece. Use the small color graphic block on each pattern page for your fabric choice color reference. Sew together with a standard ¼″ seam. *These pieces do not have fusible webbing on the back.* This will make up the background of each block. Press seams toward the dark fabric. You will place your fused appliqué pieces on this pieced background to complete the block. (Refer to Creating Block Backgrounds for All Blocks on page 8.)

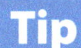

The background rectangles for the sky and land are generous (6¾″) so that you can trim the block to 6½″ square. When trimming, be sure to position the seamline correctly according to the layout.

2. You can print the pattern pieces from the CD or trace them. If tracing, trace each numbered element separately onto tracing paper. Be sure to write the number onto the traced piece matching the pattern. (Refer to Translucent Patterning and Tracing on page 8.)

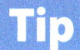

You might want to jot down the color of the traced piece to help in matching fabric and assembly.

3. Rough cut all traced or printed pattern pieces and separate individual traced pieces into piles based on colors to be used.

Rough cut traced pattern pieces of same color.

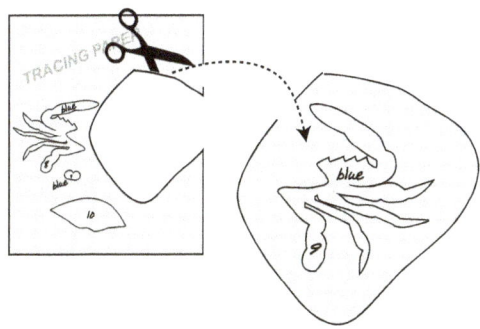

Reminder: There is no need to cut the traced patterns on exact lines at this time. Just rough cut each piece.

4. Take a pile of like-colored traced or printed pattern pieces and lay them out on the actual fabric to get a rough idea of how much fabric you will need. Position the pieces close together, but not overlapping, to use the fabric efficiently. With sharp scissors, rough cut enough fabric to make all the pieces fit on the chosen fabric. Set the traced pieces aside and make a pile of "to be fused" fabrics. You will fuse all your rough cuts at one time for efficiency.

Place same-color traced pattern pieces on fabric choice and rough cut block of fabric to be fused.

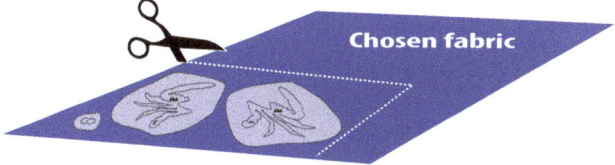

5. Once you have rough cut all the fabrics, you are ready to fuse. Lay out enough fusible webbing to accommodate all of your fabric pieces.

6. Sandwich your fabric with fusible webbing between nonstick appliqué pressing sheets to protect your iron and ironing surface.

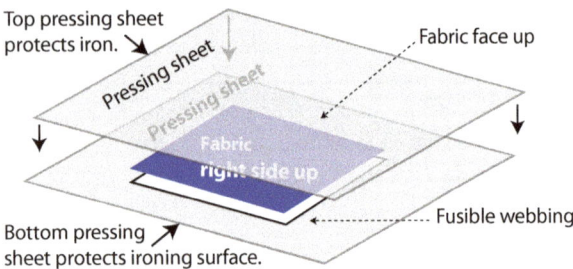

7. Following the manufacturer's instructions for heat and timing, fuse fabric swatches to the webbing. Iron the top of the nonstick appliqué sheet sandwich; then flip and iron the opposite side. Applying heat from both sides ensures a good bond of the fusible webbing to the fabric.

8. Let the nonstick appliqué sandwich cool before removing the fused fabric. Clean off any fusible webbing debris left behind on the pressing sheets.

9. Rough cut the fused fabrics apart.

10. Rematch the rough-cut pattern pieces with the correct fused fabric swatches.

11. Pin all rough-cut pattern pieces *right side up* to the appropriate fused fabric, also *right side up*.

Tip

Small pieces can be held in place with temporary glue, low-adhesive tape, or a small spot of double-sided tape.

12. With sharp scissors, carefully cut out each pattern piece on the lines. After all the patterns are cut, you will be ready to position. *Do not remove pins or backing* at this point.

13. Position your pattern pieces on your background fabric by referring to the numbered translucent pattern as your guide. Remove the pins and backing from each piece as you go. Position pieces numerically, starting with pieces 3, 4, 5, and so on. (*Reminder:* Pieces 1 and 2 are your sky and land pieces.)

Tip

Do not try to remove fused backing by picking at edges or corners. Simply take a pin and score the back of the pattern piece in the middle. Gently bend the score until the backing separates. Then tear away from the middle. You do not want to fray fabric by picking at corners or edges.

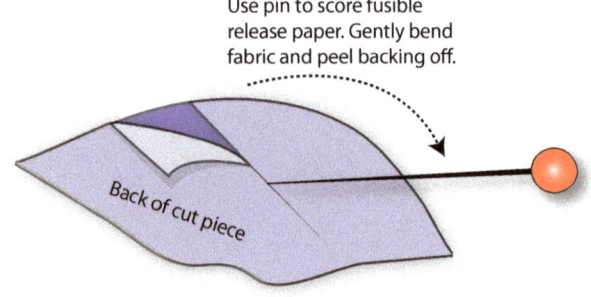

14. Once your block is in position, lay your clean appliqué pressing sheet over the top and fuse all elements into place, following the manufacturer's instructions. If the fusible you are using requires steam for the final set, remove the pressing sheet and steam as instructed after the block is pressed into position. The Warm Company's Lite Steam-A-Seam 2 produces the best results for me. Remember that steam cannot penetrate through nonstick appliqué pressing sheets. Once pressed, your block is complete and ready for stitching.

Tip

If your project includes organza or tulle, use a muslin cloth barrier in those areas when fusing for the final set. The muslin will protect the organza or tulle but will allow steam to penetrate.

15. Depending on the size of your project, there are different steps for stitching down your fused appliqué. I use a somewhat tight, narrow zigzag in my raw-edge appliqué. I often describe this stitch as a dense zigzag or an open satin stitch. Because the density of stitching can cause the fabric to pucker, it's important to stabilize the block. With smaller projects, you can stabilize with the batting; for larger projects, you can use stabilizer, as described on page 13.

Small project: If you have a small project that will be easy to manipulate in your sewing machine, sandwich only the top and batting at this point. If desired, add borders to the top that has appliqués that are fused but that are not yet stitched. Carefully iron the border seams toward darker fabric. Place a layer of Mistyfuse between the top and the batting. Fuse the top to the batting, ironing in the center first and carefully ironing to edges, avoiding any wrinkles. Now the project is fused to the batting and the batting becomes the stabilizer.

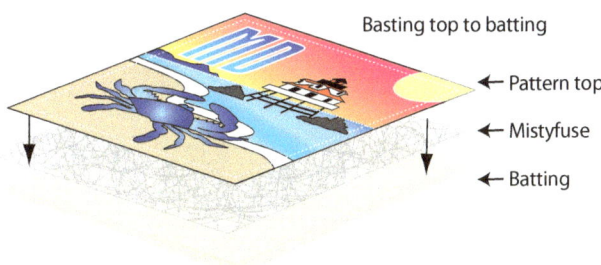

When sewing, the dense zigzag stitches will be on the back of the batting. After all the raw-edge stitching is complete, cover the batting with the backing before quilting the whole sandwich. You may be wondering whether the batting will sew with ease without fabric on the back. I have found that if you use high-quality, low-loft batting, there is no problem. The Warm Company's Warm & Natural Needled Cotton Batting is excellent for this purpose. You just need to clean your machine with every sewing session, which you should be doing regularly anyway.

Large project: Larger projects are easier to handle if you stitch down the raw-edge appliqué on each block before adding the sashing and borders. There are many stabilizers on the market. I use a tear-away stabilizer. You can also use wash-away stabilizers, stay-in stabilizers, or even freezer paper. Whichever way you choose, you need to get the block stable before zigging around all the pieces with dense stitching. Once you have stitched down the appliqué on all of your blocks, you can sash and border to complete the top.

Next you will be ready to add batting. Place a layer of Mistyfuse between the top and the batting. Then fuse the top to the batting. I start ironing in the center and carefully iron to the edges, *going slowly to avoid any wrinkles.*

> **Tip**
>
> Be sure your top is square. Do not pull fabric while fusing to avoid distorting the top onto the batting. Sometimes this distortion can work to your advantage when you have an area that is warped, but other times, pulling the top can result in undesired effects.

16. Whether your project is small or large, you will now apply the finished raw-edged top and batting to the backing. Place another layer of Mistyfuse under the top/batting and fuse it to the backing. Once again, start ironing in the center and carefully iron to the edges, avoiding any wrinkles. This method is great for small or large projects in place of basting. It will make a quilt sandwich flat as a pancake with no pins, plastic, or basting stitches to avoid and remove. The fusing and batting materials recommended will leave the sandwich light, flexible, and easy to work with and care for.

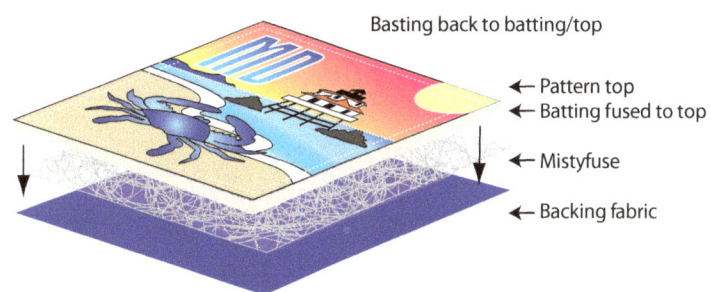

> **Tip**
>
> Be sure your top is square. Do not pull fabric while fusing to avoid distorting the backing. Fuse from the center out.

17. Quilt your project. I always start quilting by stitching the entire quilt in the ditch between blocks and borders. This generally secures the whole quilt. Then I usually go back and work from the center out with custom quilting. Your fused sandwich is very stable. You can twist and manipulate the sandwich without any worries of wrinkles or distortion during quilting by using Mistyfuse to replace pinning or hand stitching as basting.

18. Once your whole project is quilted, you can bind and enjoy looking at a wonderful piece that will always remind you of *Where Ya' Been?*

> **Tip**
>
> Put a label on the back with your name and the name of the quilter, if someone quilted it for you. Include the completion or gifting date. Many of my students have used ink-jet printable fabric and written a narrative about each block included on the label.

General Block Directions

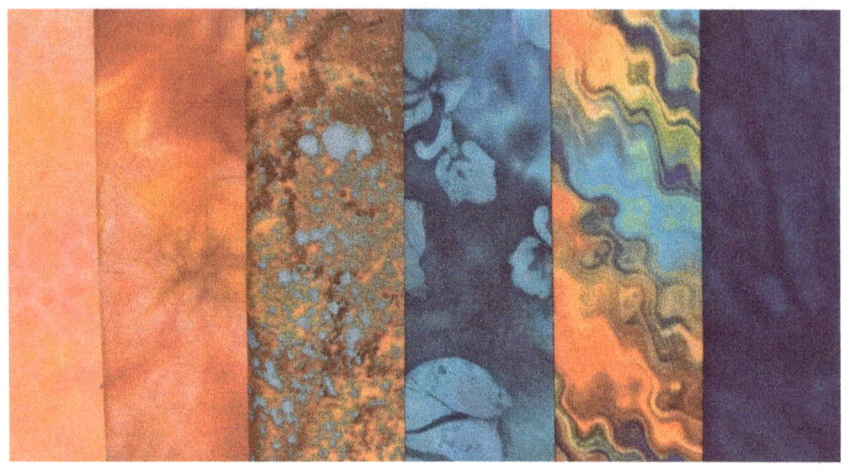

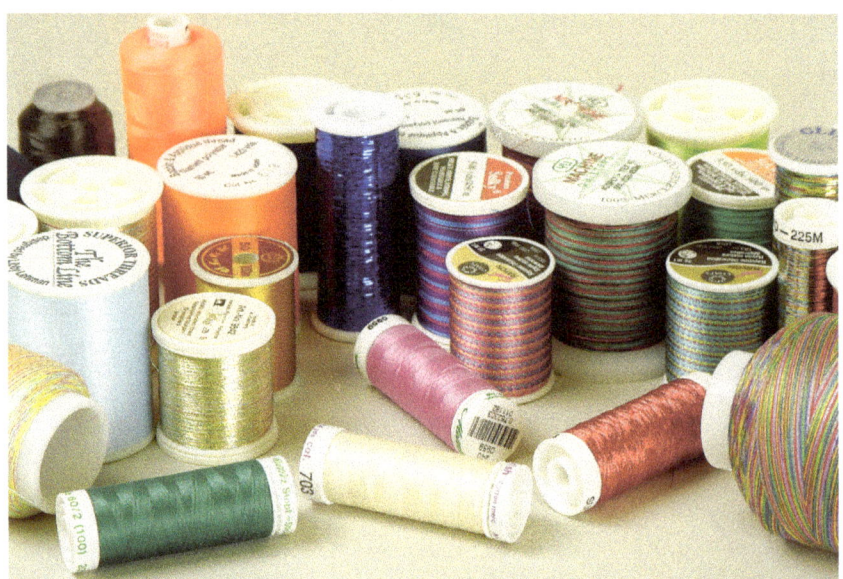

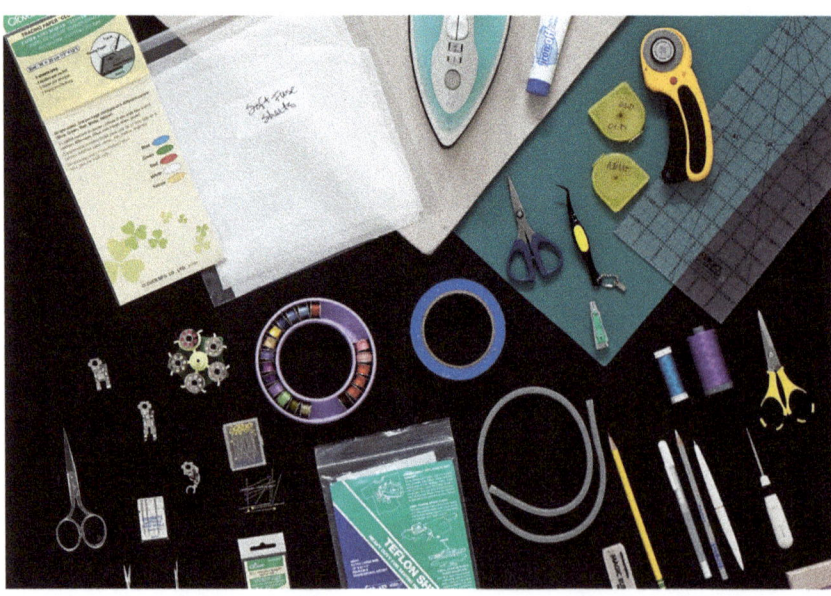

Supplies

As you know, there are many brands of all quilting supplies. I have tried many of these supplies and have come up with the following list as my staples. Of course, as with any project, you can use whatever you feel most comfortable with.

It is important for me to tell you that my supply preferences evolved over time, independent of any relationships with the manufacturers or suppliers of these products, and they were chosen based on superior performance and appearance in my projects over the past ten years.

Fabric

I try to use batiks as often as possible. I have found that batiks are more tightly woven and typically fray less than printed fabrics. I have always used fabrics from high-quality quilt shops, even before shops became customers for my patterns and classes. Hoffman California Fabrics has an extensive line of colored batiks called Bali Hand-dyed Watercolors (Style #1895), which works very well. This Hoffman line has hundreds of colors that are readily available at local quilt stores. These fabrics read as solid prints, yet offer rich batik markings.

Fusible Web

I use The Warm Company's Lite Steam-A-Seam 2. This fusible webbing is backed *and* faced with release paper. Most other fusibles have release paper on only one side. The Lite Steam-A-Seam 2 top sheet, when removed, exposes the tacky fusible. The tack is great for holding fabric in position while fusing with a hot iron. Pieces do not slide and scoot in unwanted positions. This product comes in packages and as yardage on bolts. When the front is fused to the fabric and the back release paper is then removed, the back side fusible is also tacky. This is great for temporary positioning. (Fusibles that are slick on the back make sliding pieces an issue.) Once all pieces are in place, you steam them. The steam makes a permanent bond. If you try to remove the pieces after they have been steamed, it will ruin the fabric. This is the kind of permanent hold you want. Having an excellent fuse is very important when doing raw-edge appliqué.

Appliqué Pressing Sheets

I use Bear Thread Design's Appliqué Pressing Sheet. The jumbo pressing sheet, which measures 30˝ × 27˝, is a translucent white sheet that you can see through for positioning. This huge pressing sheet makes a sandwich within which fusing can be done well and easily. I place half the large sheet on my ironing surface and place my "ready to be fused" pieces and webbing on that half. Then I fold the other half of the pressing sheet on top of the fabric. The top half protects the iron from melted fusible webbing. The bottom half provides the same protection for the ironing surface. Even the most experienced quilter can have a brain freeze and end up with a fused iron surface, which is a real mess! Folding the jumbo pressing sheet in half with fabric and fusing sandwiched in the middle guarantees no mess. Using two smaller pressing sheets will accomplish the same sandwich effect. I have found that when I sandwich the appliquéd pieces in this manner, I can conveniently and thoroughly iron both the top and bottom of the sandwich to evenly melt the fusible over every spot of the pattern pieces. If I miss a spot when fusing the top, chances are that I will get it on the back. Ironing both the top and the bottom helps avoid peeling fusible that was missed with heat.

Rotary Cutters

I use a standard rotary cutter and sharp blades. If I get a burr in the cutting wheel, I change the blade immediately. I also use the rotary cutters for making any straight-edged shapes. For example, if I am cutting ten small windows that are the same size, I will cut one long strip with the rotary cutter, and then subcut that strip into individual windows. If a building has a square for the main part, I will measure and cut that shape with the rotary cutter. I find it much easier to cut straight lines in this way rather than with scissors.

Scissors

I use sharp, top-brand scissors. I have a large pair and a small appliqué pair. When you are cutting out small, intricate appliqué pieces, you do not want to be fighting with dull scissors that can fray edges. I get my scissors sharpened twice a year *before* they show wear.

Tear-Away Stabilizer

I use this product to appliqué a block that will be in a large quilt. I raw edge all of the blocks with tear-away stabilizer and then sash or join the project, making a complete top. For small projects, I simply fuse the whole top and baste the top to my batting with Mistyfuse. The batting acts as the stabilizer and gives the project some dimension, even before adding the backing and quilting it.

Batting

I like The Warm Company's Warm & Natural Needled Cotton Batting. It has no resins or glues. It does not beard and can be quilted up to 10˝ apart if you want to quilt lightly. I like the thin batting; in my experience, it sews easily. This product is dependable and washes great.

Threads

I only use top-quality threads. My projects use either YLI, WonderFil, or Madiera threads. These threads will not cause lint buildup on the working parts of the machine, thus preventing inoperability or, worse, damage.

Sometimes I use invisible threads from either SewArt International or YLI. Invisible threads are great when they work. In my experience, these two brands are the most reliable invisible threads.

Typically I use 40-weight poly embroidery threads in the top, which provide luster to finished projects. I typically use a lighter 60-weight bobbin thread, which allows the top thread to lie on the surface better. Matching the top and bobbin thread colors is your best bet for avoiding tension picking. That said, to save time, I do often use white, black, medium gray, or tan bobbins with a colored top thread. I match the color value—light with white, medium with medium gray or tan, and darks with black. Most often, I adjust the tension so the top thread pulls down toward the back slightly. This ensures against bobbin picking.

For embellishing, I like Kreinik's beautiful decorative threads, because they carry a wide array of metallics, blends, and twists that can add unique hand-stitched details to your work.

Sewing Machine

For raw-edge appliqué, any machine that can sew a zigzag and a straight stitch will do. The features that I find very helpful are needle down and knee lift. The needle down feature allows me to stop stitching with the needle in the down position. This makes for easy pivoting on curves and corners. The knee lift allows me to more quickly loosen the grab of the presser foot for rotation and pivoting. These features are very nice but not necessary.

I do clean my machine each time I sit down to sew. I am a quick worker but would not skip this step. A poorly running machine can be due to lint buildup. Good-quality thread and cleaning will help keep the machine running well. Listen carefully to your sewing machine. As soon as you hear your machine sounding "funny," stop. Clean the bobbin area, rethread the top thread, rethread the bobbin, and try again. Many times these simple steps of cleaning and rethreading stop a problem from developing.

Open-Toe Foot

I use an open-toe foot for my appliqué, because it allows me to see the needle piercing the fabric edge with every stitch. In my experience, clear closed-toe feet distort the edge slightly, making it hard to appliqué right on the edge. Regular feet, with the metal piece surrounding the needle on the foot, obstruct the appliqué's edge where you need to be sewing.

Basting with Mistyfuse

Basting is one of those things we all have to do but most of us dread. I have basted with pins. However, although pins are reusable, they are tough on your fingers, make quilts very heavy, and require putting all the pins in and taking all the pins out. I have also used a basting gun, which shoots plastic tacks through all three layers of a quilt. However, those tacks also have to be removed and can leave large holes from the gun. Of course, you can hand baste, but this also takes time and has to be removed. I do not use any of these methods anymore. Instead, I use Mistyfuse as my basting. This amazing product was developed by quilter Iris Karp of attached inc. in Brooklyn, New York. Mistyfuse is a very soft, light fusible product. It is like angel hair that is spread very thinly on a Christmas tree. The product does not behave like paper-backed fusible, which can separate in heat and gum up in humidity. Mistyfuse comes in black and white and will not stiffen your project.

Workspace

I believe strongly in the value of having a clean workspace. This saves time and results in the highest-quality finished project. If your workspace is cluttered and dirty, you will spend more time looking for things and sorting than you do creating. I make it a point to tidy up each day after I am finished working; that way, I will be ready to start again with a clear mind the next time I get to work. Faced with a cluttered, disorganized space, I often do not want to start the project again. It can take a long time just to figure out where I left off.

Alabama (AL)

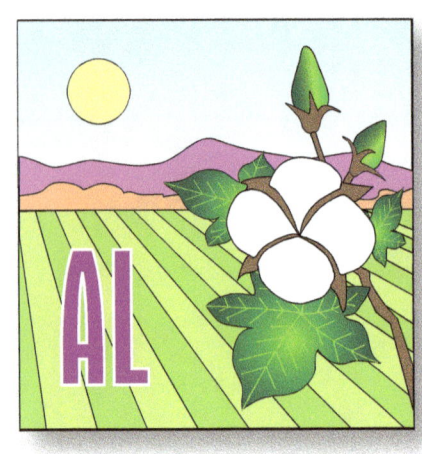

"The Cotton State" was the 22nd state to enter the Union, admitted in 1819. It is located in the middle of an area often referred to as the Bible Belt. The climate is temperate, with very hot summers, mild winters, and abundant precipitation throughout the year. The name Alabama *means "vegetation gatherers,"* which was coined by Choctaw Indians in the 1540s. While many Southern states are known for their cotton crops, Alabama is the Cotton State because it is located in the center of the Cotton Belt. Another nickname for Alabama is *"The Heart of Dixie."*

DIRECTIONS

Cut a 3½˝ × 6¾˝ rectangle for the sky (piece 1) and a 4½˝ × 6¾˝ rectangle for the land (piece 2). Leave excess to square and trim the block later. Sew the sky/land together with a ¼˝ seam to make the background. Position the sky/land by lining up the horizon line. Trace, cut, position, and fuse the remaining pieces in place. You might use fleece or wool for white cotton in the plant to give the cotton texture. After sewing the raw edges, trim and square the block to 6½˝ × 6½˝.

Alaska (AK)

"The Last Frontier" was the 49th state to enter the Union, admitted in 1959. It is the largest state, with myriad islands, millions of lakes, and nearly 34,000 miles of shoreline. Alaska is north of the lower 48 states, above Washington, and is bordered by Canada and the Bering, Beaufort, and Chukchi seas. Alaska's climate varies widely. State capital, Juneau, averages more than 50 inches of precipitation a year, while other areas receive more than 275 inches a year. Alaska is home to exquisite wildlife, including the polar bear. The beautiful Aurora Borealis (Northern Lights) can be seen in Alaska.

DIRECTIONS

Cut a 3½″ × 6¾″ rectangle for the sky (piece 1) and a 4½″ × 6¾″ rectangle for the land (piece 2). Leave excess to square and trim the block later. Sew the sky/land together with a ¼″ seam to make the background. Position the sky/land by lining up the horizon line. Trace, cut, position, and fuse the remaining pieces in place. A hand-dyed or painted fabric works well for the Northern Lights sky. Fabric paint or fabric markers would be best for the bear's eye, bear's nose, and snow details on evergreen trees. After sewing the raw edges, trim and square the block to 6½″ × 6½″.

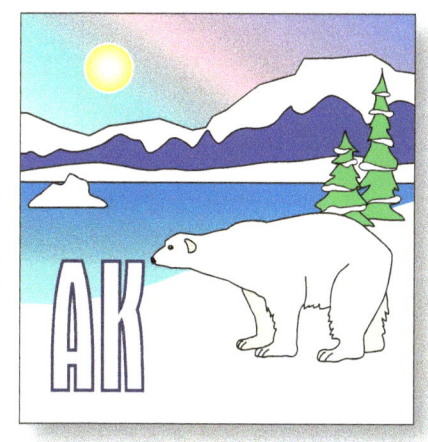

Patterns 19

Arizona (AZ)

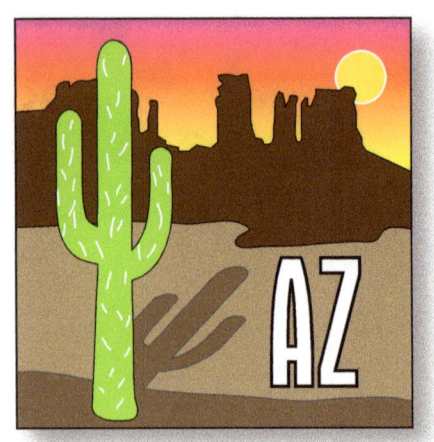

"The Grand Canyon State" was the 48th state to enter the Union, admitted in 1912. Arizona is known for its desert climate, extremely hot summers, low rainfall levels, and mild winters. The northern high country has pine forests and mountain ranges with cooler weather. The Grand Canyon, Cathedral Rock, and Meteor Crater, as well as many national forests, parks, monuments, and Indian reservations, are located in this state. The Arizona desert landscape is covered in xerophytes, such as the cactus.

DIRECTIONS

Cut a 3½″ × 6¾″ rectangle for the sky (piece 1) and a 4½″ × 6¾″ rectangle for the land (piece 2). Leave excess to square and trim the block later. Sew the sky/land together with a ¼″ seam to make the background. Position the sky/land by lining up the horizon line. Trace, cut, position, and fuse the remaining pieces in place. Hand stitching the cactus thorns with thick, decorative threads creates an interesting texture. After sewing the raw edges, trim and square the block to 6½″ × 6½″.

Arkansas (AR)

"The Natural State" was the 25th state to enter the Union, admitted in 1836. Its diverse natural features range from the mountain regions of the Ozarks and Ouachita mountains to the eastern lowlands along the Mississippi River, which forms the state's eastern border. Arkansas has hot, humid summers and cold, slightly drier winters. The Old Mill in northern Little Rock, located in Pugh's Mill Park, is a life-sized sculpture by Dionysio Rodrigues. It was built in 1933 as a replica of the facility that actually milled grain a century earlier. This mill was seen in the classic movie Gone with the Wind. *In 1986, the Old Mill was placed on the National Register of Historic Places.*

DIRECTIONS

Cut a 3½″ × 6¾″ rectangle for the sky (piece 1) and a 4½″ × 6¾″ rectangle for the land (piece 2). Leave excess to square and trim the block later. Sew the sky/land together with a ¼″ seam to make the background. Position the sky/land by lining up the horizon line. Trace, cut, position, and fuse the remaining pieces in place. The water swirls, sunrays (if included), branch bridges, mill wheel, doorpost, and window details can be created with fabric paint. After sewing the raw edges, trim and square the block to 6½″ × 6½″.

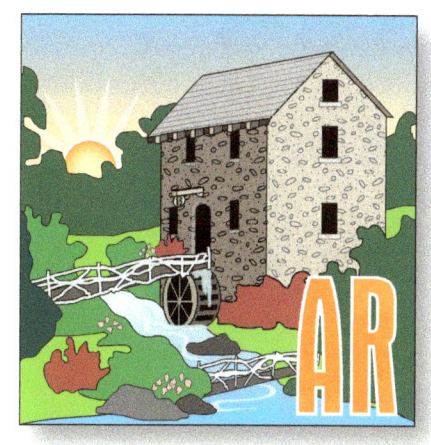

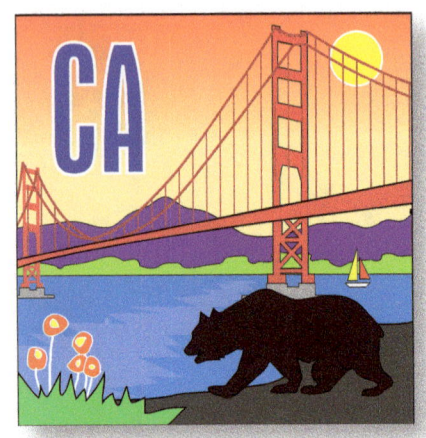

California (CA)

"The Golden State" was the 31st state to enter the Union, admitted in 1850. California has very diverse climates. Death Valley, at 282 feet below sea level, has a recorded high temperature of 132°F, while Mount Whitney, at 14,494 feet above sea level, has temperatures that can drop to −40°F. The Golden Gate Bridge is one of the world's most recognizable structures. The orange-red color is the sealant applied before the bridge was to be painted silver. The designer, Irving Marrow, liked the orange and made the final overcoat the same orange-red color. The grizzly bear and poppy are the state's animal and flower, respectively.

DIRECTIONS

Cut a 4½˝ × 6¾˝ rectangle for the sky (piece 1) and a 3½˝ × 6¾˝ rectangle for the land (piece 2). Leave excess to square and trim the block later. Sew the sky/land together with a ¼˝ seam to make the background. Position the sky/land by lining up the horizon line. Trace, cut, position, and fuse the remaining pieces in place. The poppies (piece 5) can be created with fabric paint or embroidery. The thin bridge supports (piece 15) can be drawn with fabric markers or stitched with thick red thread. After sewing the raw edges, trim and square the block to 6½˝ × 6½˝.

Colorado (CO)

"The Centennial State" was the 38th state to enter the Union, admitted in 1876. Breathtaking canyons, mountains, valleys, and the vast Rocky Mountains make Colorado a top tourist spot for skiers and others who like the outdoors. The state has snowy winters and warm summers. Denver, the state capital, is often referred to as the Mile High City, being exactly one mile above sea level. At one time, Colorado was primarily a mining and agricultural state. Today, business and professional services dominate the economy. Colorado boasts the largest natural acreage of aspen trees in the world, even though the blue spruce is the state tree. The magnificent Colorado River starts in Colorado and winds its way to Arizona through the Grand Canyon.

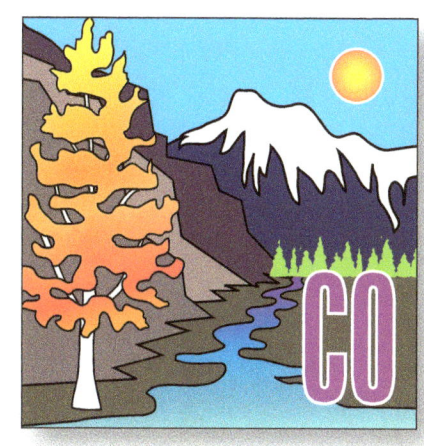

DIRECTIONS

Cut a 3½˝ × 6¾˝ rectangle for the sky (piece 1) and a 4½˝ × 6¾˝ rectangle for the land (piece 2). Leave excess to square and trim the block later. Sew the sky/land together with a ¼˝ seam to make the background. Position the sky/land by lining up the horizon line. Trace, cut, position, and fuse the remaining pieces in place. After sewing the raw edges, trim and square the block to 6½˝ × 6½˝.

Connecticut (CT)

In 1788 "The Constitution State" was the fifth of the original thirteen colonies to be admitted to the Union. Connecticut enjoys a full range of seasons, from snowy winters to hot summer days. New London's Harbor Light was the fourth lighthouse in North America. The lighthouse can be viewed from boats leaving New London, including ferries to Fishers Island, Block Island, and Montauk on Long Island. Connecticut is the origin of the lollipop, the hamburger, the Frisbee, and the household vacuum. The charter oak is Connecticut's state tree.

DIRECTIONS

Cut a 4½″ × 6¾″ rectangles for the sky (piece 1) and a 3½″ × 6¾″ rectangle for the land (piece 2). Leave excess to square and trim the block later. Sew the sky/land together with a ¼″ seam to make the background. Position the sky/land by lining up the horizon line. Trace, cut, position, and fuse the remaining pieces in place. The small windows on the lighthouse and building can be embroidered or painted with fabric paint. The sunrays could be included as a tulle overlay that is sewn during quilting. Pieces 7 and 13 are shadows that can be made with black tulle. After sewing the raw edges, trim and square the block to 6½″ × 6½″.

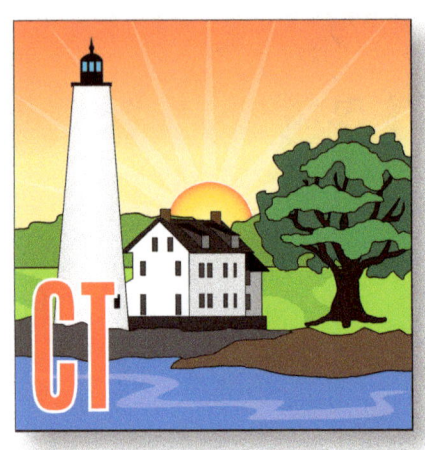

Delaware (DE)

"The First State" was the first of the original colonies to be admitted to the Union, after ratifying the Constitution in 1787. Delaware, the second-smallest state, is on the mid-Atlantic coastline. The Delaware Memorial Bridge, the world's longest twin suspension design, is a memorial to soldiers who died in World War II, the Korean War, Vietnam, and Operation Desert Storm. Thomas Jefferson described Delaware as "a 'jewel' among states due to its strategic location on the Eastern Seaboard," which led the nickname, The Diamond State.

DIRECTIONS

Cut a 4½″ × 6¾″ rectangle for the sky (piece 1) and a 3½″ × 6¾″ rectangle for the land (piece 2). Leave excess to square and trim the block later. Sew the sky/land together with a ¼″ seam to make the background. Position the sky/land by lining up the horizon line. Trace, cut, position, and fuse the remaining pieces in place. The vertical supports on the bridge can be made with a simple straight stitch or fabric markers. The red lights on the bridge, the diamond details, and the shovel shadow can be created with fabric paint or markers. The sunrays could be included as a tulle overlay or simply eliminated. After sewing the raw edges, trim and square the block to 6½″ × 6½″.

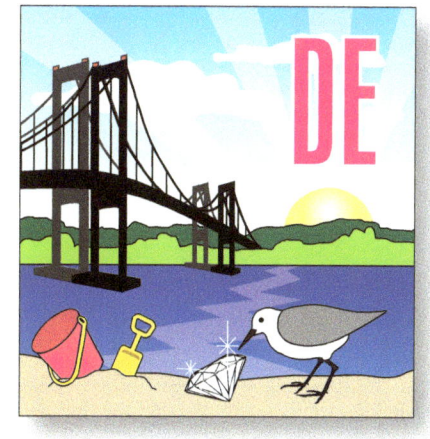

Delaware

Patterns 25

District of Columbia (DC)

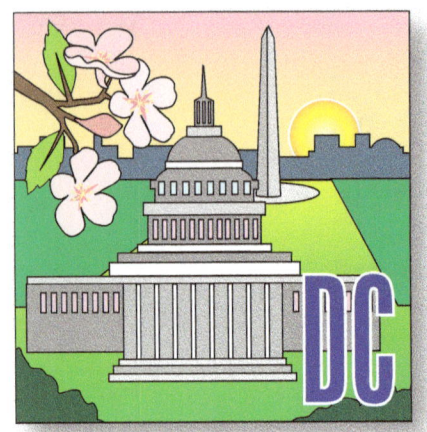

Washington, D.C., was co-named after Christopher Columbus, the famed explorer, and George Washington, the first president. The Capitol building, the Washington Monument, the Lincoln Memorial, and the World War II Memorial are just a few of the historic sites along the almost-one-mile-long mall area. The Cherry Blossom Festival is an annual event held in March, featuring the blossoming trees that line the heart of the D.C. area and the Potomac River. The original 3,020 cherry trees were presented as a gift to the United States from Mayor Yukio Ozaki of Tokyo, Japan, in 1912.

DIRECTIONS

Cut a 3½˝ × 6¾˝ rectangle for the sky (piece 1) and a 4½˝ × 6¾˝ rectangle for the land (piece 2). Leave excess to square and trim the block later. Sew the sky/land together with a ¼˝ seam to make the background. Trace, cut, position, and fuse the remaining pieces in place. The Capitol building (piece 12) is all one piece behind the entire building. The cherry blossom centers, windows, and building columns can be painted with fabric paint or embroidered. After sewing the raw edges, trim and square the block to 6½˝ × 6½˝.

Quilt Blocks Across America

Florida (FL)

"The Sunshine State" was the 27th state to enter the Union, admitted in 1845. Sunshine, orange blossoms, and palm trees make this state a tropical paradise. Florida has hot, humid weather, with very mild winters. Just below Saint Augustine, our nation's oldest city, stands the Saint Augustine Lighthouse on Anastasia Island. Wild flamingos frequent Key West and south Florida's national parks in search of food. Dolphins are one of Florida's favorite marine life mammals. They can be seen just off the shores of the Atlantic and in the Gulf of Mexico.

DIRECTIONS

Cut a 3½″ × 6¾″ rectangle for the sky (piece 1) and a 4½″ × 6¾″ rectangle for the land (piece 2). Leave excess to square and trim the block later. Sew the sky/land together with a ¼″ seam to make the background. Position the sky/land by lining up the horizon line. Trace, cut, position, and fuse the remaining pieces in place. The lighthouse windows and the flamingo eye can be created with embroidery, fabric paint, or markers. The sunrays could be included as a tulle overlay or simply eliminated. After sewing the raw edges, trim and square the block to 6½″ × 6½″.

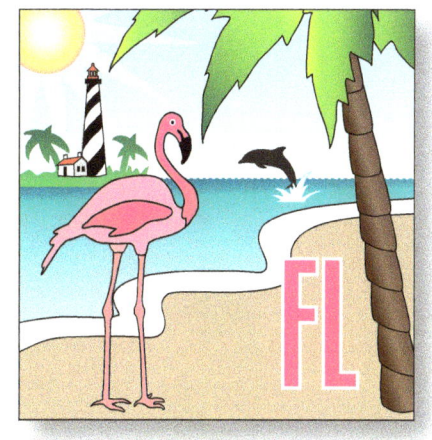

Georgia (GA)

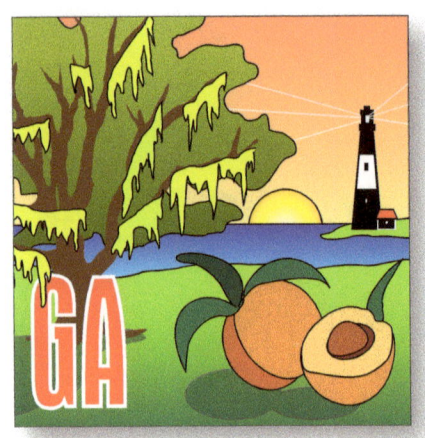

"The Peach State" was the fourth of the original thirteen colonies to be admitted to the Union, after ratifying the Constitution in 1788. In general, this Southern state has a humid, subtropical climate. Most of the state has mild winters and hot, humid summers. Peaches and peanuts are the main crops for this Atlantic coastal state. The live oak is the state tree. Savannah boasts streets lined with beautiful oaks with signature Spanish moss draping from the branches. The impeccably kept Tybee Island Lighthouse, erected in 1732, has been providing mariners safe entry into the Savannah River for more than 270 years.

DIRECTIONS

Cut a 4½″ × 6¾″ rectangle for the sky (piece 1) and a 3½″ × 6¾″ rectangle for the land (piece 2). Leave excess to square and trim the block later. Sew the sky/land together with a ¼″ seam to make the background. The small windows on the lighthouse can be created with fabric paint, or they can be embroidered. Position the sky/land by lining up the horizon line. Trace, cut, position, and fuse the remaining pieces in place. After sewing the raw edges, trim and square the block to 6½″ × 6½″.

28 Quilt Blocks Across America

Hawaii (HI)

"The Aloha State" was the last state to enter the Union, admitted in 1959. Hawaii has eight main islands and many smaller islands. The state has warm tropical temperatures all year. Some of the world's best surfers flock to Hawaii for its famous giant waves. The Hawaiian Islands are the exposed peaks of an undersea mountain range known as the Hawaiian-Emperor seamount chain, formed by volcanic activity. The hibiscus is Hawaii's state flower. The Kilauea Lighthouse can be seen on the northeast coastline of Kauai. Hawaii is one of the world's most desired vacation spots and is steeped in unique Hawaiian history and culture.

DIRECTIONS

Cut a 3½″ × 6¾″ rectangle for the sky (piece 1) and a 4½″ × 6¾″ rectangle for the land (piece 2). Leave excess to square and trim the block later. Sew the sky/land together with a ¼″ seam to make the background. The small details on the lighthouse can be painted with fabric paint or embroidered. The yellow spokes on the hibiscus stamen translate well with hand stitching of thick embroidery thread. Position the sky/land by lining up the horizon line. Trace, cut, position, and fuse the remaining pieces in place. After sewing the raw edges, trim and square the block to 6½″ × 6½″.

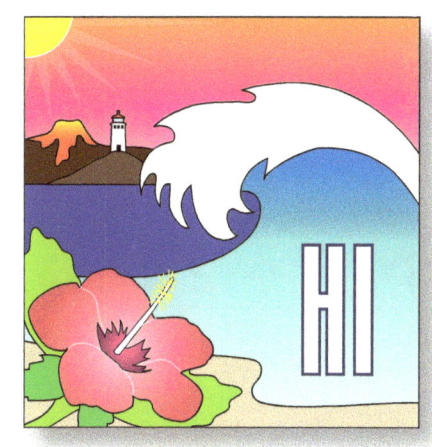

Idaho

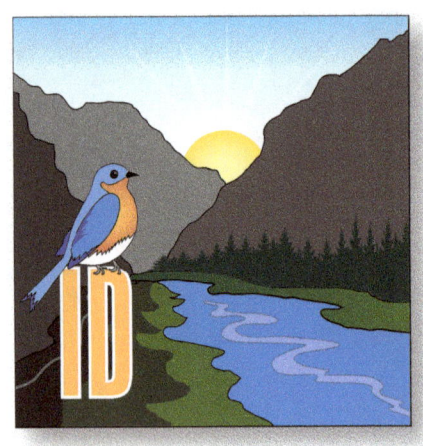

Idaho (ID)

"The Gem State" was the 43rd state to enter the Union, admitted in 1890. Idaho is a mountainous state that owes its nickname to the presence of nearly every known gem. Hells Canyon, a ten-mile-wide canyon carved by the Snake River, is located along the border of eastern Oregon and the peaks of Idaho's Seven Devils mountain range. It is North America's deepest river gorge, at 7,993 feet. As a northwestern state, Idaho can get quite cold, but it enjoys moderate summers. Potatoes, dairy, and cattle are Idaho's leading agricultural commodities. The mountain bluebird and the white pine are Idaho's state bird and tree.

DIRECTIONS

Cut a 3½˝ × 6¾˝ rectangle for the sky (piece 1) and a 4½˝ × 6¾˝ rectangle for the land (piece 2). Leave excess to square and trim the block later. Sew the sky/land together with a ¼˝ seam to make the background. The bluebird's eye and feet can be created with fabric paint, markers, or embroidery. If included, the sunrays and water highlight can be made from white organza or tulle. Position the sky/land by lining up the horizon line. Trace, cut, position, and fuse the remaining pieces in place. After sewing the raw edges, trim and square the block to 6½˝ × 6½˝.

30 Quilt Blocks Across America

Illinois (IL)

"The Prairie State" was the 21st state to enter the Union, admitted in 1818. Illinois derived its nickname from its many flat prairies of tall grass with wildflowers. Illinois has a temperate climate, with cold, snowy winters and hot, wet summers. The port of Chicago is located where the Great Lakes connect to the Mississippi River. Chicago is the state's largest city and is, in my opinion, one of the most exciting places to be in the United States. The cardinal and the violet are the state's bird and flower, respectively. The name Illinois *is derived from the Native American Algonquin language and means "tribe of superior men."*

DIRECTIONS

Cut a 3½˝ × 6¾˝ rectangle for the sky (piece 1) and a 4½˝ × 6¾˝ rectangle for the land (piece 2). Leave excess to square and trim the block later. Sew the sky/land together with a ¼˝ seam to make the background. The cardinal's eye, the violet centers, and the scattered field flowers can be created with fabric paint or embroidery. Trace, cut, position, and fuse the remaining pieces in place. After sewing the raw edges, trim and square the block to 6½˝ × 6½˝.

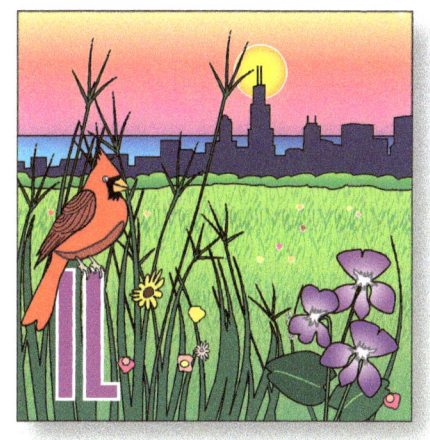

Patterns

Indiana (IN)

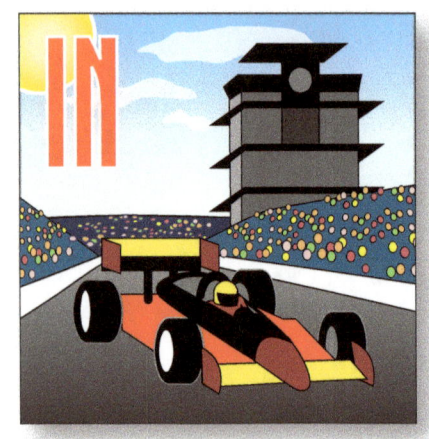

"The Hoosier State" was the nineteenth state to enter the Union, admitted in 1816. Indiana has a humid continental climate, with cool winters and warm, wet summers. A small 40-mile coastline on Lake Michigan justifies Indiana's inclusion as a Great Lakes state. Arguably one of the greatest spectacles in sports, the Indianapolis 500 auto race is held every Memorial Day weekend in the capital city. Car racing, basketball, football, and just about every other sport are very important to Hoosiers. Corn, peppermint, spearmint, tomatoes, and soybeans are some of Indiana's principal crops. Some of the highest-quality quarried limestone in the United States is extracted from Indiana.

DIRECTIONS

Cut a 4½˝ × 6¾˝ rectangle for the sky (piece 1) and a 3½˝ × 6¾˝ rectangle for the land (piece 2). Leave excess to square and trim the block later. Sew the sky/land together with a ¼˝ seam to make the background. If included, the clouds can be made from white organza or tulle. The crowd in the bleachers can be created by using a multicolored polka dot fabric or by painting the heads with fabric paint. Trace, cut, position, and fuse the remaining pieces in place. After sewing the raw edges, trim and square the block to 6½˝ × 6½˝.

Quilt Blocks Across America

Iowa (IA)

"The Hawkeye State" was the 29th state to enter the Union, admitted in 1846. The nickname *Hawkeyes* honors Chief Black Hawk, a Native American war chief mentioned in the historic 1826 novel *The Last of the Mohicans, by James Fenimore Cooper*. Like most Midwest states, Iowa has a humid continental climate, with cold winters and warm summers. Iowa has many rolling hills and is located in the center of what is commonly called the American Heartland. Once known only as a major agricultural producer of corn, oats, and dairy products, Iowa now has a vital mix of industry and finance. Iowa's state flower is the beautiful wild rose.

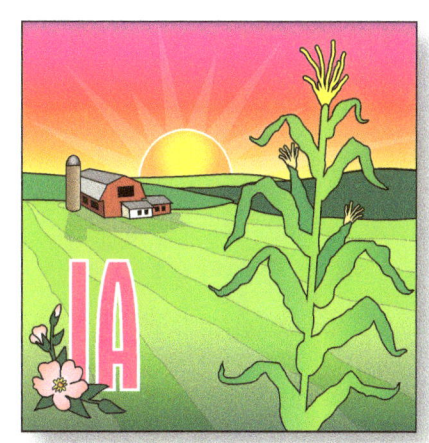

DIRECTIONS

Cut a 3½″ × 6¾″ rectangle for the sky (piece 1) and a 4½″ × 6¾″ rectangle for the land (piece 2). Leave excess to square and trim the block later. Sew the sky/land together with a ¼″ seam to make the background. If included, the sunrays can be made from white organza or tulle. The small barn windows and wild rose details can be created with fabric paint or embroidery. Trace, cut, position, and fuse the remaining pieces in place. After sewing the raw edges, trim and square the block to 6½″ × 6½″.

Kansas (KS)

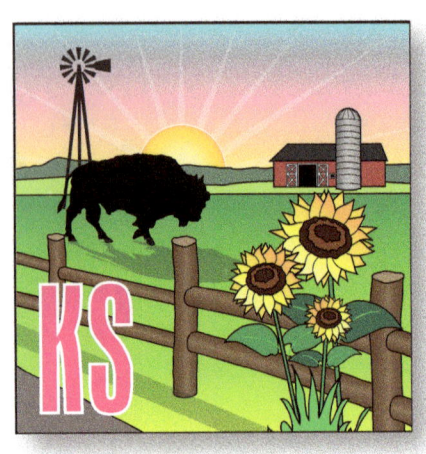

"The Sunflower State" was the 34th state to enter the Union, admitted in 1861. Kansas means "people of the south wind" in the Native American Sioux Indian language. The state was named after the Kansas River. Two-thirds of the state has a generally flat surface. The eastern third has many hills and forests. The eastern two-thirds of the state have cool to cold winters and hot, humid summers. The western third of the state has very hot, less humid summers. Winters are highly changeable between warm and very cold. Grains, cattle, hogs, and wheat are major agricultural commodities in Kansas. The American bison is the state animal.

DIRECTIONS

Cut a 3½″ × 6¾″ rectangle for the sky (piece 1) and a 4½″ × 6¾″ rectangle for the land (piece 2). Leave excess to square and trim the block later. Sew the sky/land together with a ¼″ seam to make the background. Trace, cut, position, and fuse the remaining pieces in place. The barn details can be created with fabric markers. After sewing the raw edges, trim and square the block to 6½″ × 6½″.

Kentucky (KY)

"The Bluegrass State" was the fifteenth state to enter the Union, admitted in 1792. Kentucky has varied terrain. The Appalachian and Cumberland mountains cross the state north to south on the east. Kentucky's northern border is formed by the Ohio River, and its western border, by the Mississippi River. Kentucky has four distinct seasons every year. The state's nickname is based on the rich bluegrass found in many of the state's rolling pastures. The bluegrass and rich soil help feed the famous thoroughbred horses raised in this state. The Kentucky Derby is held annually at the world-famous Churchill Downs. Kentucky is also home to the quilting capital of the world in Paducah.

DIRECTIONS

Cut a 3½˝ × 6¾˝ rectangle for the sky (piece 1) and a 4½˝ × 6¾˝ rectangle for the land (piece 2). Leave excess to square and trim the block later. Sew the sky/land together with a ¼˝ seam to make the background. Trace, cut, position, and fuse the remaining pieces in place. The crowd in the stands (piece 20) can be created with a multicolor random polka dot fabric. The quilt on the racehorse's back can be painted or fussy cut from a novelty fabric. After sewing the raw edges, trim and square the block to 6½˝ × 6½˝.

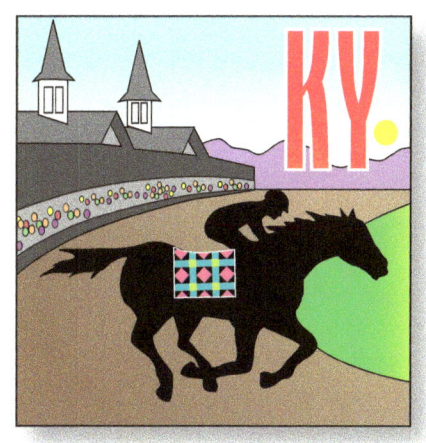

Louisiana (LA)

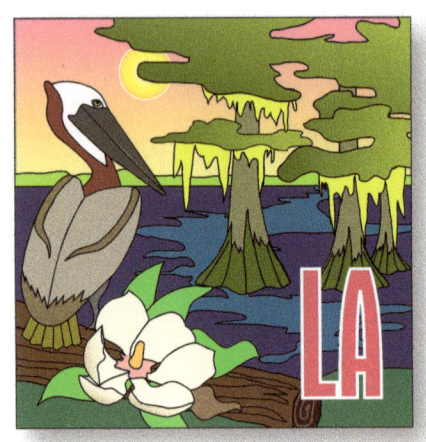

"The Bayou State" was the eighteenth state to enter the Union, admitted in 1812. The middle and southern areas of the state are low-lying swamplands, coastal marshes, and beaches. The higher lands and hills of the north and northwest consist of prairie and woodlands. The highest point in the state is only 535 feet above sea level. Louisiana has long, hot, humid summers and mild, short winters. The Red River and Ouachita River branch into many bayous, which are filled with Spanish moss–draped cypress trees. Louisiana has huge fishing and forest industries. Crops grown in this southern state are sugarcane, rice, cotton, sweet potatoes, soybeans, and pecans. The brown pelican and the magnolia are the state's bird and flower, respectively.

DIRECTIONS

Cut a 3½″ × 6¾″ rectangle for the sky (piece 1) and a 4½″ × 6¾″ rectangle for the land (piece 2). Leave excess to square and trim the block later. Sew the sky/land together with a ¼″ seam to make the background. Trace, cut, position, and fuse the remaining pieces in place. The pelican's eye can be drawn with fabric markers or embroidered. After sewing the raw edges, trim and square the block to 6½″ × 6½″.

Maine (ME)

"The Pine Tree State" was the 23rd state to enter the Union, admitted in 1820. Maine is the northernmost Appalachian state of New England and the easternmost state in the Union. It is well known for its many mountains and its ocean scenery, including Portland Head Lighthouse in Cape Elizabeth. Originally built in 1791, this is Maine's oldest lighthouse. Temperatures in Maine are fairly warm and humid in summer with long, cold, snowy winters. Forestry and fishing are some of Maine's principal industries. Maine is known for its blueberries, apples, and maple syrup—and along its Atlantic coast for some of the best lobsters in the world.

DIRECTIONS

Cut a 3½″ × 6¾″ rectangle for the sky (piece 1) and a 4½″ × 6¾″ rectangle for the land (piece 2). Leave excess to square and trim the block later. Sew the sky/land together with a ¼″ seam to make the background. Trace, cut, position, and fuse the remaining pieces in place. The lighthouse light rays can be created with white organza or tulle. The lighthouse details can be created with either fabric paints or markers. After sewing the raw edges, trim and square the block to 6½″ × 6½″.

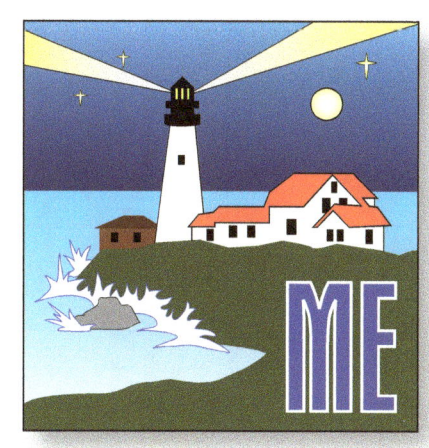

Maryland (MD)

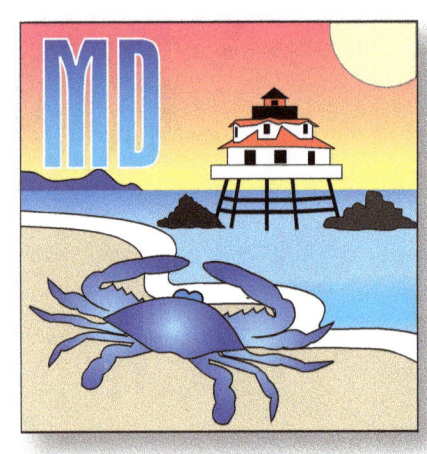

"The Old Line State" was the seventh of the original thirteen colonies to be admitted to the Union, after ratifying the Constitution in 1788. The Appalachian Mountains run through the far western region of Maryland. The state experiences four distinct seasons, where hot, humid summers are contrasted with moderately cold winters, with some snowfall each year. The short and stout Thomas Point Shoal Lighthouse is located on the Chesapeake Bay and is the most recognized lighthouse in Maryland. Biology, medicine, and technology are some of Maryland's leading industries. Maryland blue crabs and coastal beaches are state treasures.

DIRECTIONS

Cut a 3½″ × 6¾″ rectangle for the sky (piece 1) and a 4½″ × 6¾″ rectangle for the land (piece 2). Leave excess to square and trim the block later. Sew the sky/land together with a ¼″ seam to make the background. Trace, cut, position, and fuse the remaining pieces in place. The lighthouse supports can be created with fabric markers or straight stitching. The small details on the lighthouse can be created with fabric marker or paint. After sewing the raw edges, trim and square the block to 6½″ × 6½″.

Massachusetts (MA)

"The Bay State" was the sixth of the original thirteen colonies to be admitted to the Union, after ratifying the Constitution in 1788. Several large bays shape the state's Atlantic coast and give Massachusetts its nickname. The Appalachian Mountains run through the western part of the state. Massachusetts has severe winters with warm summers. The *Ernestina, an 1894 globe-traveling schooner now docked in New Bedford, was named a national historic landmark in 1990. America's first lighthouse, the Boston Lighthouse, was built in Boston Harbor in 1716. The mayflower is the state's flower.*

DIRECTIONS

Cut a 3½″ × 6¾″ rectangle for the sky (piece 1) and a 4½″ × 6¾″ rectangle for the land (piece 2). Leave excess to square and trim the block later. Sew the sky/land together with a ¼″ seam to make the background. Trace, cut, position, and fuse the remaining pieces in place. If included, the sunrays can be created with white organza or tulle. The small flower parts and lighthouse details can be created with fabric paint or markers. The schooner ropes can be made with fabric marker or straight stitching. After sewing the raw edges, trim and square the block to 6½″ × 6½″.

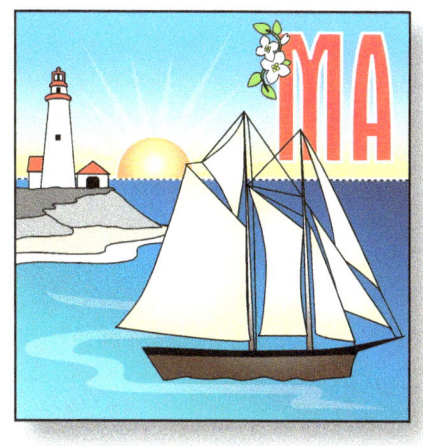

Michigan (MI)

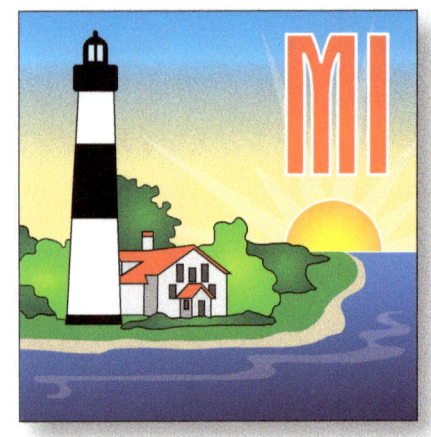

"The Wolverine State" was the 26th state to enter the Union, admitted in 1837. Michigan is the only state to consist entirely of two peninsulas bordered by four of the five Great Lakes. The Upper Peninsula is heavily forested and mountainous to the west. The generally flat Lower Peninsula, shaped like a mitten, occupies nearly two-thirds of the state's land area. The Lower Peninsula has hot summers and cold winters. The Upper Peninsula has short, warm summers and long, very cold winters. Michigan has the most lighthouses in the United States. Built in 1867, Big Sable Point Lighthouse was an important landmark for mariners traveling a treacherous stretch of Lake Michigan.

DIRECTIONS

Cut a 4½″ × 6¾″ rectangle for the sky (piece 1) and a 3½″ × 6¾″ rectangle for the land (piece 2). Leave excess to square and trim the block later. Sew the sky/land together with a ¼″ seam to make the background. Trace, cut, position, and fuse the remaining pieces in place. If included, the sunrays can be made from white organza or tulle. The lighthouse details can be created with fabric markers. After sewing the raw edges, trim and square the block to 6½″ × 6½″.

Minnesota (MN)

"The Land of 10,000 Lakes" was the 32nd state to enter the Union, admitted in 1858. Minnesota contains some of the oldest rocks found on Earth. The state has many steep, rocky hills, as well as streams that cut into the bedrock. It has more than 10,000 lakes, each more than 10 acres in size, with Lake Superior being the largest. Minnesota has 10.6 million acres of wetlands. Residents endure extremely cold winters and very hot summers. The record high is 114°F, and the record low is −60°F. Picturesquely located at the top of a rocky shore on Lake Superior is the landmark Split Rock Lighthouse. The common loon is Minnesota's state bird.

DIRECTIONS

Cut a 3½″ × 6¾″ rectangle for the sky (piece 1) and a 4½″ × 6¾″ rectangle for the land (piece 2). Leave excess to square and trim the block later. Sew the sky/land together with a ¼″ seam to make the background. Trace, cut, position, and fuse the remaining pieces in place. The sunrays can be created with white organza or tulle. The lighthouse details can be created with fabric markers or embroidery. After sewing the raw edges, trim and square the block to 6½″ × 6½″.

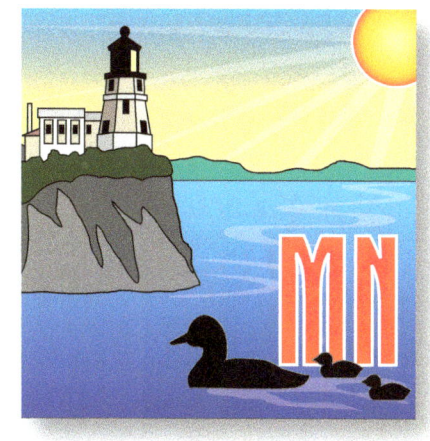

Mississippi

Mississippi (MS)

"The Magnolia State" was the 20th state to enter the Union, admitted in 1817. Mississippi is entirely composed of lowlands; the highest point, in the Cumberland Mountains, is 806 feet above sea level. Mississippi is known for its long, hot summers and short, mild winters. The Mississippi River flows through this southern state, with many alligators in nearby swamps and bayous. Steamboats still paddle up and down the Mississippi River. They can navigate in shallow waters as well as power upriver against strong currents. The Biloxi Lighthouse is located next to the Mississippi Sound, off the Gulf of Mexico in Biloxi.

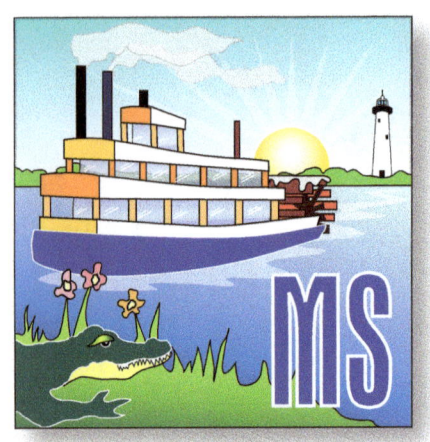

DIRECTIONS

Cut a 3½″ × 6¾″ rectangle for the sky (piece 1) and a 4½″ × 6¾″ rectangle for the land (piece 2). Leave excess to square and trim the block later. Sew the sky/land together with a ¼″ seam to make the background. Trace, cut, position, and fuse the remaining pieces in place. If included, the sunrays can be created with white organza or tulle. Small lighthouse details, flower centers, and the gator's eye and teeth can be created with fabric markers or embroidery. After sewing the raw edges, trim and square the block to 6½″ × 6½″.

42

Quilt Blocks Across America

Missouri (MO)

"The Show-Me State" was the 24th state to enter the Union, admitted in 1821. North of the Missouri River are gentle rolling hills, while the southern region rises to the Ozark Mountains. The southeastern part of the state is the lowest, flattest, and wettest. This Midwestern state is named for the Native American Missouri Indian tribe and means "town of the large canoes." Missouri experiences cold winters and hot, humid summers. The Gateway Arch, also known as the Gateway to the West, is an integral part of St. Louis. Completed in 1965, it stands 630 feet tall and is 630 feet wide at its base, making it the tallest monument in the United States. Some of the state's main agricultural products are beef, soybeans, pork, dairy, corn, poultry, cotton, rice, and eggs.

DIRECTIONS

Cut a 4½˝ × 6¾˝ rectangles for the sky (piece 1) and a 3½˝ × 6¾˝ rectangle for the land (piece 2). Leave excess to square and trim the block later. Sew the sky/land together with a ¼˝ seam to make the background. Trace, cut, position, and fuse the remaining pieces in place. The rope (piece 12) on the boat can be made with thick embroidery floss. After sewing the raw edges, trim and square the block to 6½˝ × 6½˝.

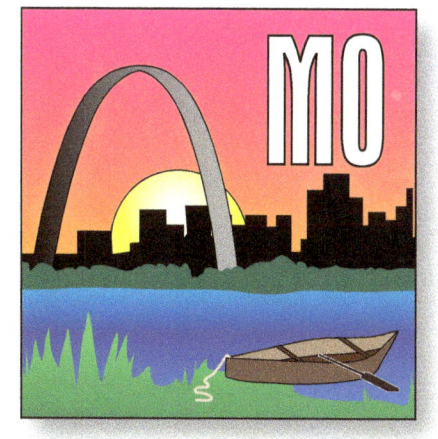

Patterns

Montana (MT)

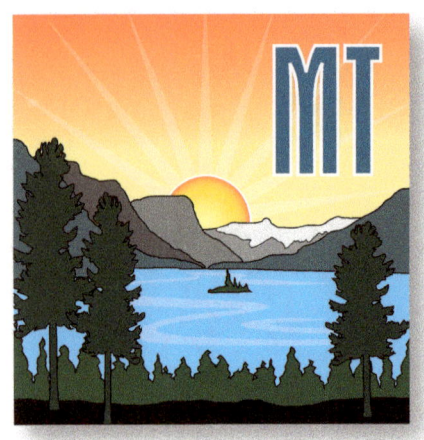

"The Treasure State" was the 41st state to enter the Union, admitted in 1889. Montana boasts 77 named ranges of the Rocky Mountains, validating the state's name in Spanish, montaña, which means "mountain." About 60 percent of the state is prairie and is part of the northern Great Plains. The weather varies greatly in Montana, as the state has high-altitude mountains that can be snowcapped almost all year. St. Mary Lake, one of Montana's 650 lakes, is found in Waterton Glacier International Peace Park. The snowcapped mountains are steep, wild, and pristine. Although the state is large in area, it is sparse in population. Montana is named the Treasure State because of its rich mineral reserves, which have yielded fortunes in sapphires, gold, and silver since the 1800s.

DIRECTIONS

Cut a 4½˝ × 6¾˝ rectangle for the sky (piece 1) and a 3½˝ × 6¾˝ rectangle for the land (piece 2). Leave excess to square and trim the block later. Sew the sky/land together with a ¼˝ seam to make the background. Trace, cut, position, and fuse the remaining pieces in place. If included, the sunrays can be created with white organza or tulle. After sewing the raw edges, trim and square the block to 6½˝ × 6½˝.

Nebraska (NE)

"The Cornhusker State" was the 37th state to enter the Union, admitted in 1867. The eastern half of the state has undulating farmlands with rich soil. The Sand Hills fan out to the west and are stabilized by grass coverage. Cattle graze on slopes that are protected through the severe winters by sand bluffs and valleys. Short, hot summers contrast with long, brutal winters. Rainfall is almost twice as heavy in the east as in the west. Corn, soybeans, dairy, cattle, and hog farming lead Nebraska's agricultural products. Farmlands with grain elevators are common sites throughout the state.

DIRECTIONS

Cut a 3½″ × 6¾″ rectangle for the sky (piece 1) and a 4½″ × 6¾″ rectangle for the land (piece 2). Leave excess to square and trim the block later. Sew the sky/land together with a ¼″ seam to make the background. Trace, cut, position, and fuse the remaining pieces in place. The corn shadow (piece 19) can be created with black organza or tulle. The corn (piece 22) is best created with a printed texture fabric. The grain elevator details can be created with fabric markers. After sewing the raw edges, trim and square the block to 6½″ × 6½″.

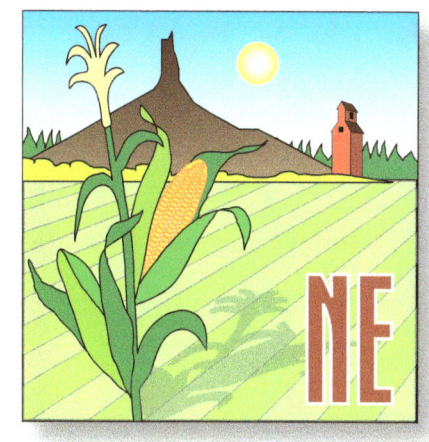

Nevada (NE)

"The Silver State" was the 36th state to enter the Union, admitted in 1864. The nickname was coined during the silver rush days of the mid-1800s. Nevada is made up mostly of desert and arid climate regions, with very hot summers and very cold winter nights. The average annual rainfall per year is about 7 inches. Sierra Nevada bighorn sheep, recognized as a unique subspecies, live in the cooler mountainous regions of the Sierra Nevada mountain range. This unique species, particular to Nevada, is currently on the U.S. endangered species list. The gorgeous Sierra Nevadas, Hoover Dam, Death Valley, Mohave Desert, and Lake Tahoe are some of Nevada's notable landmarks.

DIRECTIONS

Cut a 3½″ × 6¾″ rectangle for the sky (piece 1) and a 4½″ × 6¾″ rectangle for the land (piece 2). Leave excess to square and trim the block later. Sew the sky/land together with a ¼″ seam to make the background. Trace, cut, position, and fuse the remaining pieces in place. After sewing the raw edges, trim and square the block to 6½″ × 6½″.

46 Quilt Blocks Across America

New Hampshire (NH)

In 1788 "The Granite State" was the ninth of the original thirteen colonies to be admitted to the Union. The state nickname reflects its geology and its tradition of self-sufficiency. New Hampshire has short, warm, humid summers, with extreme "wicked" cold, wet winters. The state's major recreational attractions include skiing, snowmobiling, hiking, and observing the fall foliage. Vacation homes and cottages along New Hampshire's many lakes are recreation retreats. The Old Man of the Mountain, a facelike profile in Franconia Notch, was a state landmark until the formation fell apart in May 2003. The White Mountains span the northern part of the state and are home to Mount Washington, the tallest peak in the northeastern United States. A common site in northern New Hampshire is moose in fields and near water.

DIRECTIONS

Cut a 3½˝ × 6¾˝ rectangle for the sky (piece 1) and a 4½˝ × 6¾˝ rectangle for the land (piece 2). Leave excess to square and trim the block later. Sew the sky/land together with a ¼˝ seam to make the background. Trace, cut, position, and fuse the remaining pieces in place. The moose shadow can be produced with light blue organza or tulle. After sewing the raw edges, trim and square the block to 6½˝ × 6½˝.

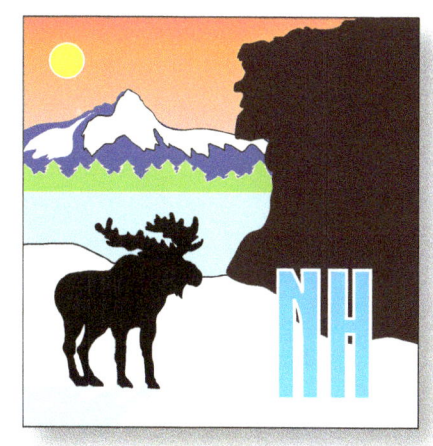

Patterns 47

New Jersey

New Jersey (NJ)

In 1787 "The Garden State" was the third of the original colonies to be admitted to the Union. New Jersey is the most densely populated state in the United States. The northern sector is wooded, while the east has a long Atlantic coastal shoreline. The center of the state is in the Delaware Valley, and the southern sector is heavily covered by pine and oak forests. New Jersey has four distinct seasons. In 2009, President Barack Obama signed legislation authorizing the 77-foot Paterson Great Falls, the nation's second largest waterfall by volume east of the Mississippi River, as a new national historical park. The Garden State is the second-largest producer of blueberries in the United States and third in the nation for cranberries.

DIRECTIONS

Cut a 3½˝ × 6¾˝ rectangle for the sky (piece 1) and a 4½˝ × 6¾˝ rectangle for the land (piece 2). Leave excess to square and trim the block later. Sew the sky/land together with a ¼˝ seam to make the background. Trace, cut, position, and fuse the remaining pieces in place. If included, the sunrays can be created with white organza or tulle. The blueberry details can be created with fabric paint. After sewing the raw edges, trim and square the block to 6½˝ × 6½˝.

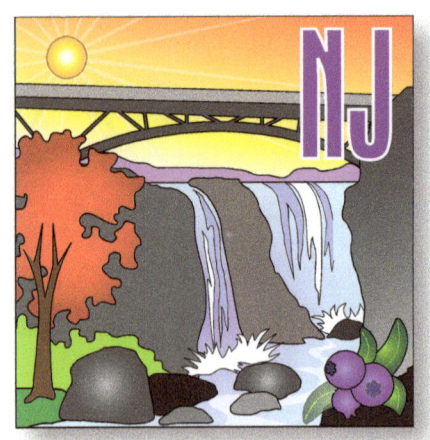

48

Quilt Blocks Across America

New Mexico (NM)

"The Land of Enchantment" was the 47th state to enter the Union, admitted in 1912. The New Mexico landscape includes wide rose-colored deserts, steep broken cliffs, heavily forested areas in the north, and high snowcapped peaks. New Mexico is highly arid with very hot temperatures, especially during the long summers. More than a million people travel to the state to see the Albuquerque International Balloon Fiesta, when hundreds of beautifully colored hot air balloons take flight. Shiprock, in the northwest, is a basalt core volcanic neck remnant of an eruption that occurred about 30 million years ago. The roadrunner and the yucca are the state bird and state flower, respectively.

DIRECTIONS

Cut a 4½″ × 6¾″ rectangle for the sky (piece 1) and a 3½″ × 6¾″ rectangle for the land (piece 2). Leave excess to square and trim the block later. Sew the sky/land together with a ¼″ seam to make the background. Trace, cut, position, and fuse the remaining pieces in place. The shadow (pieces 15–16) can be created with black organza or tulle. Roadrunner details can be created with fabric markers. After sewing the raw edges, trim and square the block to 6½″ × 6½″.

Patterns 49

New York

New York (NY)

"The Empire State" was the eleventh of the original thirteen colonies to be admitted to the Union, after ratifying the Constitution in 1788. The vast rugged Adirondack Mountains lie west of the Hudson River Valley. Most of the southern part of the state is on the Allegheny Plateau, which rises from the southeast to the Catskill Mountains. New York enjoys a full range of seasons. New York City, the most populated city in the United States, is referred to as the gateway for immigration, symbolized by the Statue of Liberty, which stands proudly in the Big Apple's New York Harbor. New York State is home to the American side of Niagara Falls, renowned for both their beauty and their valued source of hydroelectric power. The western edge of the state touches Lake Erie and Lake Ontario.

DIRECTIONS

Cut a 3½″ × 6¾″ rectangle for the sky (piece 1) and a 4½″ × 6¾″ rectangle for the land (piece 2). Leave excess to square and trim the block later. Sew the sky/land together with a ¼″ seam to make the background. Trace, cut, position, and fuse the remaining pieces in place. After sewing the raw edges, trim and square the block to 6½″ × 6½″.

Quilt Blocks Across America

North Carolina (NC)

"The Tar Heel State" was the twelfth of the original thirteen colonies to be admitted to the Union, after ratifying the Constitution in 1789. North Carolina has a wide range of elevations, from sea level on the Atlantic coastal plain, which occupies the eastern 45 percent of the state, to more than 6,000 feet in the Great Smoky Mountains and Blue Ridge Mountains of the Appalachians. The Atlantic keeps temperatures mild in winter and moderate in summer. The state is noted for the first successful air flight by the Wright brothers in 1903. The Cape Hatteras Lighthouse is located on Hatteras Island. The state flower is the dogwood.

DIRECTIONS

Cut a 4½″ × 6¾″ rectangle for the sky (piece 1) and a 3½″ × 6¾″ rectangle for the land (piece 2). Leave excess to square and trim the block later. Sew the sky/land together with a ¼″ seam to make the background. Trace, cut, position, and fuse the remaining pieces in place. Pieces 3–5 can be created with white organza or tulle to create a translucent effect. The shadows (pieces 13 and 21) can be created with black organza or tulle. Details on the lighthouse and dogwood flowers can be created with fabric markers or paint. After sewing the raw edges, trim and square the block to 6½″ × 6½″.

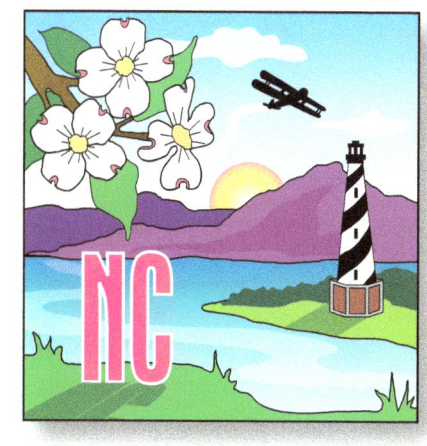

Patterns 51

North Dakota

North Dakota (ND)

"The Peace Garden State" was the 39th state to enter the Union, admitted in 1889. The state consists of the hilly Great Plains and the Badlands, which are in the north, located west of the Missouri River. Some of the most extreme temperature variations on the planet are experienced in North Dakota's severe winters and scorching summers. It is the most rural state in the nation, with farms covering more than 90 percent of the landscape. Established in 1932, the Waterton Glacier International Peace Park straddles the U.S. and Canadian border. North Dakota produces grains, sunflowers, dry beans, honey, sugar beets, beef cattle, sheep, and hogs. Its state bird is the western meadowlark.

DIRECTIONS

Cut a 3½″ × 6¾″ rectangle for the sky (piece 1) and a 4½″ × 6¾″ rectangle for the land (piece 2). Leave excess to square and trim the block later. Sew the sky/land together with a ¼″ seam to make the background. Trace, cut, position, and fuse the remaining pieces in place. The barn and bird details can be created with fabric markers. If included, the sunrays can be created with white organza or tulle. After sewing the raw edges, trim and square the block to 6½″ × 6½″.

52 Quilt Blocks Across America

Ohio (OH)

"The Buckeye State" was the seventeenth state to enter the Union, admitted in 1803. Most of Ohio is low relief and rolling hills. However, the Allegheny Plateau contains rugged hills and forests. Ohio's several state borders are defined by water, with the Ohio River to the south and Lake Erie to the north. Ohio summers are typically hot and humid, with winters ranging from cool to quite cold. The state is known for its abundance of Ohio buckeye trees. Keeping a buckeye nut in one's pocket is considered good luck. Operating since 1822, the Marblehead Lighthouse is the oldest lighthouse in continuous service on the Great Lakes. The red carnation and the red cardinal are the state flower and bird, respectively.

DIRECTIONS

Cut a 3½″ × 6¾″ rectangle for the sky (piece 1) and a 4½″ × 6¾″ rectangle for the land (piece 2). Leave excess to square and trim the block later. Sew the sky/land together with a ¼″ seam to make the background. Trace, cut, position, and fuse the remaining pieces in place. The bird's eye and lighthouse details can be created with fabric markers or embroidery. Shadows (pieces 23 and 28) can be created with black organza or tulle. After sewing the raw edges, trim and square the block to 6½″ × 6½″.

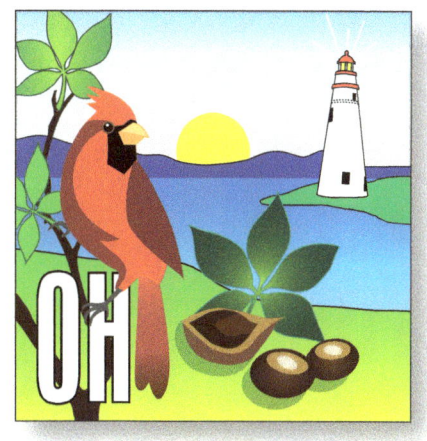

Patterns 53

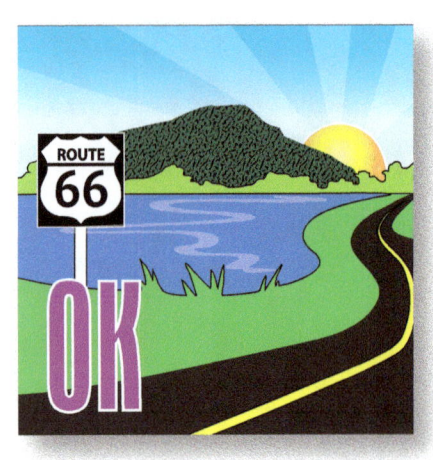

Oklahoma (OK)

"The Sooner State" was the 46th state to enter the Union, admitted in 1907. Oklahoma is a series of flat plains divided by rolling hills, ridges, and the Ozark and Ouachita mountains. The panhandle is a rich grassland area that gently rises into rocky mesas. Oklahoma is particularly prone to severe weather, especially tornadoes. Hot, humid summers and cold winters define the climate in this central state. Route 66 is a famous road that goes across the entire state of Oklahoma. Landlocked Oklahoma has more human-made lakes than any other state in the United States. Broken Bow Lake is a major Oklahoma reservoir and a favorite of nature enthusiasts throughout the region.

DIRECTIONS

Cut a 3½˝ × 6¾˝ rectangle for the sky (piece 1) and a 4½˝ × 6¾˝ rectangle for the land (piece 2). Leave excess to square and trim the block later. Sew the sky/land together with a ¼˝ seam to make the background. Trace, cut, position, and fuse the remaining pieces in place. If included, the sunrays can be created with white organza or tulle. The composite Route 66 road sign (page 70) can be copied and printed onto fabric, if preferred. After sewing the raw edges, trim and square the block to 6½˝ × 6½˝.

Oregon (OR)

"The Beaver State" was the 33rd state to enter the Union, admitted in 1859. Oregon enjoys a diverse landscape, with a picturesque Pacific coastline, volcanoes in the Cascade Mountain range, dense evergreen forests, and a high desert across much of the eastern part of the state. The climate is generally mild, though periods of extreme hot and cold can affect different parts of the state. Precipitation in the state varies widely. Formed by the collapse of land following a volcanic eruption, south central Oregon's Crater Lake is nearly 4,000 feet deep. Crater Lake's waters are considered among the world's clearest. Crater Lake National Park is the only national park in Oregon.

DIRECTIONS

Cut a 3½″ × 6¾″ rectangle for the sky (piece 1) and a 4½″ × 6¾″ rectangle for the land (piece 2). Leave excess to square and trim the block later. Sew the sky/land together with a ¼″ seam to make the background. Trace, cut, position, and fuse the remaining pieces in place. The birds (piece 14) can be created with embroidery or fabric markers. If included, the sunrays can be created with white organza. After sewing the raw edges, trim and square the block to 6½″ × 6½″.

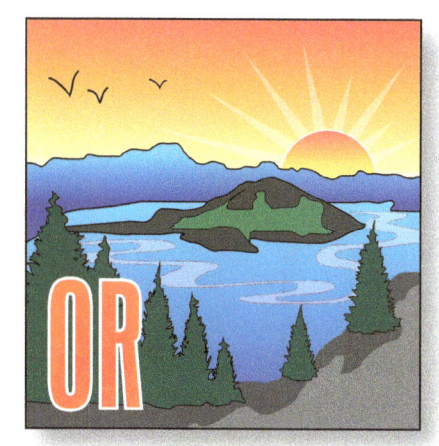

Pennsylvania

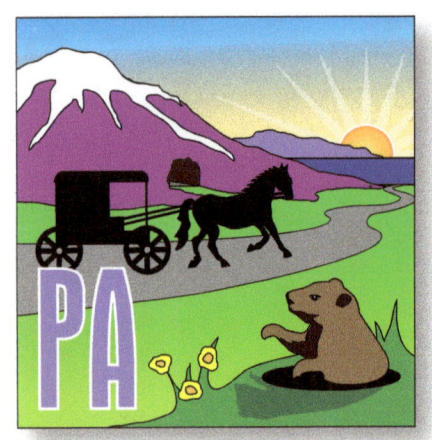

Pennsylvania (PA)

In 1787 "The Keystone State" was the second of the original colonies to be admitted to the Union. The nickname comes from the fact that it was in the "key" region of the original thirteen colonies. The first White House was in Philadelphia, which is also home to the Liberty Bell. Pennsylvania is home to the Pennsylvania Dutch Amish people, with their horse-drawn carriages and simple preindustrial lifestyle. Every February 2, in Punxsutawney, Phil the groundhog is watched by thousands to see if he will see his shadow, indicating whether winter will continue for six more weeks. Mining is a key industry in Pennsylvania.

DIRECTIONS

Cut a 3½˝ × 6¾˝ rectangle for the sky (piece 1) and a 4½˝ × 6¾˝ rectangle for the land (piece 2). Leave excess to square and trim the block later. Sew the sky/land together with a ¼˝ seam to make the background. Trace, cut, position, and fuse the remaining pieces in place. Phil the groundhog's details can be created with fabric markers. The flowers (pieces 14–16) can be created with fabric paints or embroidery. The reins on the Amish carriage can be sewn or drawn in. If included, the sunrays can be made from white organza or tulle. After sewing the raw edges, trim and square the block to 6½˝ × 6½˝.

Quilt Blocks Across America

Rhode Island (RI)

In 1790 "The Ocean State" was the last of the original colonies to be admitted to the Union. This New England state is the smallest in the nation. Most of Rhode Island is actually on the mainland and is not an island. Rhode Island has cold winters and rainy summers. It is mostly flat, with no real mountains. In fact, the state's highest natural point is only 812 feet above sea level. The state has many oceanfront beaches—hence, its nickname. Beavertail Lighthouse, built in 1749, is the premier lighthouse in Rhode Island and is found on the southernmost point of Conanicut Island in Beavertail State Park. This small state depends on fishing, farming, tourism, and manufacturing as its main industries.

DIRECTIONS

Cut a 4½″ × 6¾″ rectangle for the sky (piece 1) and a 3½″ × 6¾″ rectangle for the land (piece 2). Leave excess to square and trim the block later. Sew the sky/land together with a ¼″ seam to make the background. Trace, cut, position, and fuse the remaining pieces in place. The stars (pieces 4–6), windows, and doors can be drawn, painted, or embroidered. The light rays and water ripple (piece 36) can be created with thread, paint, white organza, or tulle. After sewing the raw edges, trim and square the block to 6½″ × 6½″.

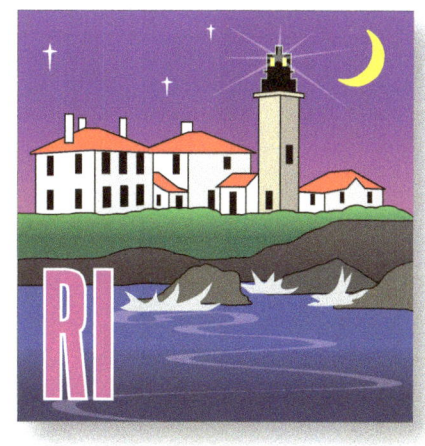

South Carolina (SC)

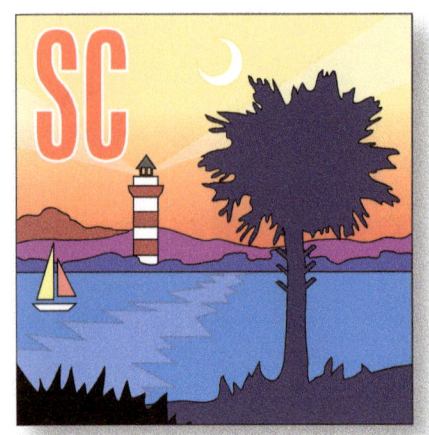

"The Palmetto State" was the eighth of the original thirteen colonies to be admitted to the Union, after ratifying the Constitution in 1788. South Carolina contains a small section of the Blue Ridge Mountains, the coastal plains known as the Low Country, and a hilly central region called the Sandhills. South Carolina is hot and humid in the summer, with very mild winter temperatures. The Savannah River makes up most of South Carolina's western border with Georgia. Hilton Head Island and its famous lighthouse draw tourists from all over to its beautiful Atlantic beaches and its many pristine golf courses. The state tree, the palmetto palm, and a white crescent moon adorn South Carolina's flag and license plates.

DIRECTIONS

Cut a 4½″ × 6¾″ rectangles for the sky (piece 1) and a 3½″ × 6¾″ rectangle for the land (piece 2). Leave excess to square and trim the block later. Sew the sky/land together with a ¼″ seam to make the background. Trace, cut, position, and fuse the remaining pieces in place. Pieces 6 and 7 can be created with white organza or tulle to get a luminous effect. The two small windows in the top of the lighthouse can be created with fabric paint or markers. After sewing the raw edges, trim and square the block to 6½″ × 6½″.

South Dakota (SD)

"Mount Rushmore State" was the 40th state to enter the Union, admitted in 1889. South Dakota has four distinct seasons. The state is divided by the Missouri River into geographically and socially distinct areas known as East River and West River. The east is the most populated part of the state, with fertile soil used to grow a variety of crops. The west is where most of the state's ranching is found. The southwestern region's Black Hills, a group of low, pine-covered mountains, are home to the famed Mount Rushmore, a monumental granite sculpture created by Gutzon Borglum from 1867 to 1941.

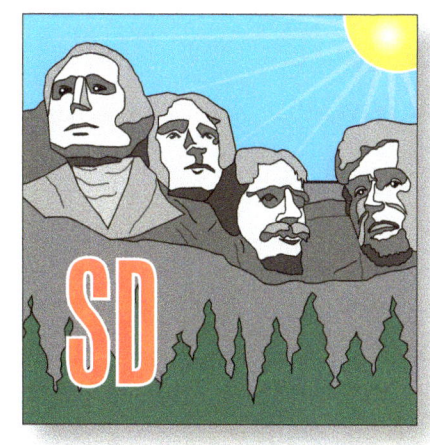

DIRECTIONS

Cut a 3½″ × 6¾″ rectangle for the sky (piece 1) and a 4½″ × 6¾″ rectangle for the land (piece 2). Leave excess to square and trim the block later. Sew the sky/land together with a ¼″ seam to make the background. This block has a special pattern on page 70 (pieces 6*–9*) or a composite from which you can copy the whole mountain face onto printable fabric. Trace, cut, position, and fuse the remaining pieces in place. If included, the sunrays can be created from white organza or tulle. After sewing the raw edges, trim and square the block to 6½″ × 6½″.

Patterns

Tennessee

Tennessee (TN)

"The Volunteer State" was the sixteenth state to enter the Union, admitted in 1796. The Blue Ridge Mountains lie on the eastern edge of Tennessee. In the state's center is the Cumberland Plateau, with its flat-topped mountains and sharp valleys. Western Tennessee is within the Gulf Coastal Plain, which is divided into three sections that extend from the Tennessee River in the east to the Mississippi River in the west. The state has hot summers and mild to cool winters, with generous precipitation throughout the year and colder conditions in the mountains. The purple iris and the mockingbird are the state flower and bird, respectively. Tobacco, cotton, and soybeans are the state's main agricultural crops.

DIRECTIONS

Cut a 3½˝ × 6¾˝ rectangle for the sky (piece 1) and a 4½˝ × 6¾˝ rectangle for the land (piece 2). Leave excess to square and trim the block later. Sew the sky/land together with a ¼˝ seam to make the background. Trace, cut, position, and fuse the remaining pieces in place. You might consider quilting wings and tail with a white contrasting thread to create a feather look. Mockingbird details can be created with fabric markers or paint. After sewing the raw edges, trim and square the block to 6½˝ × 6½˝.

60 Quilt Blocks Across America

Texas (TX)

"The Lone Star State" was the 28th state to enter the Union, admitted in 1845. Texas is the second-largest U.S. state in both area and population. The name Texas originated from a Native American Indian word for "friends." Texas has a diverse geographical profile. The landscapes range from coastal swamps and piney woods to rolling plains and rugged hills. The western parts of Texas have desert terrain, as well as the mountains of Big Bend. Being such a massive state, the climate varies from some snow in the upper panhandle to tropical weather in the lower and coastal areas. The state's most famous standing building is the Alamo, in San Antonio. Originally a Roman Catholic mission, it became famous because of a battle fought there in the war for Texas independence from Mexico in 1836.

DIRECTIONS

Cut a 4½″ × 6¾″ rectangle for the sky (piece 1) and a 3½″ × 6¾″ rectangle for the land (piece 2). Leave excess to square and trim the block later. Sew the sky/land together with a ¼″ seam to make the background. Trace, cut, position, and fuse the remaining pieces in place. The small white accents on the front Alamo posts, if used, can be created with fabric paint. After sewing the raw edges, trim and square the block to 6½″ × 6½″.

Utah (UT)

"The Beehive State" was the 45th state to enter the Union, admitted in 1896. Utah's temperatures are extreme, with frigid cold in the Rocky Mountain elevations in winter and very hot summers in the desert areas in summer. Although Utah is generally rocky, it has three distinct geological regions—the Rocky Mountains, the Great Basin, and the Colorado Plateau. The name Utah means "people of the mountains" in the Native American Ute Indian language. Approximately 80 percent of Utah's population lives in or near Salt Lake City. The famous Delicate Arch of Arches National Park is one of many interesting geological formations in Utah's five national parks. The California gull is Utah's state bird, earning this honor in 1848 by defending settler crops and food supplies from swarms of crickets.

DIRECTIONS

Cut a 4½″ × 6¾″ rectangle for the sky (piece 1) and a 3½″ × 6¾″ rectangle for the land (piece 2). Leave excess to square and trim the block later. Sew the sky/land together with a ¼″ seam to make the background. Trace, cut, position, and fuse the remaining pieces in place. The seagull's eye can be created with fabric paints or embroidery. After sewing the raw edges, trim and square the block to 6½″ × 6½″.

Vermont (VT)

"The Green Mountain State" was the fourteenth state to enter the Union, admitted in 1791. The climate of this New England state is warm and humid in summer, with cold, snowy winters and exceptionally colder temperatures at higher elevations. The annual snowfall averages between 60 inches and 100 inches. Fifty percent of Vermont's western border is made up by Lake Champlain, which is shared with neighboring New York State and Canada. The Green Mountains, which run north to south, boast great skiing and are the origin of the state's nickname. The state tree, the sugar maple, is very important to Vermont for its rich hardwood and production of maple syrup. Covered bridges grace the countryside throughout Vermont's picturesque landscape. Vermont has the highest number of covered bridges per square mile in the United States.

DIRECTIONS

Cut a 4½″ × 6¾″ rectangle for the sky (piece 1) and a 3½″ × 6¾″ rectangle for the land (piece 2). Leave excess to square and trim the block later. Sew the sky/land together with a ¼″ seam to make the background. Trace, cut, position, and fuse the remaining pieces in place. After sewing the raw edges, trim and square the block to 6½″ × 6½″.

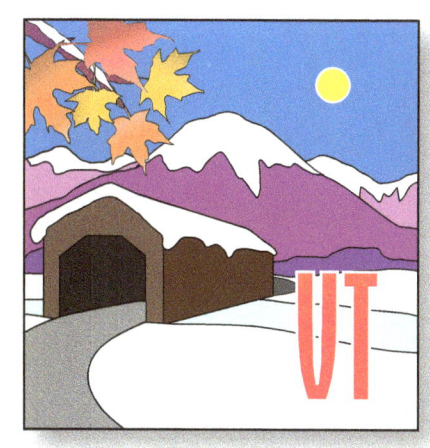

Patterns 63

Virginia (VA)

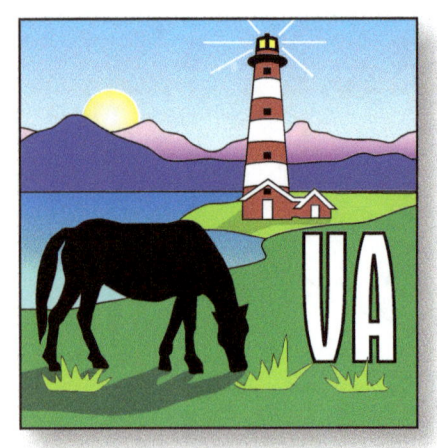

In 1788 "The Old Dominion State" was the tenth of the original thirteen colonies to be admitted to the Union. The climate of Virginia varies, with warmer temperatures found farther south and east. In the Blue Ridge Mountains and in western and northern Virginia, the winters can be very cold and snowy. Beautiful Assateague Island, located on the eastern shore, is best known for its herds of wild horses and the Assateague Lighthouse. Virginia is the birthplace of eight U.S. presidents, the most of any U.S. state. Although agriculture is by far Virginia's largest industry, the growth of technology has made computer chips the state's leading export.

DIRECTIONS

Cut a 3½" × 6¾" rectangle for the sky (piece 1) and a 4½" × 6¾" rectangle for the land (piece 2). Leave excess to square and trim the block later. Sew the sky/land together with a ¼" seam to make the background. Trace, cut, position, and fuse the remaining pieces in place. The horse and lighthouse shadows can be created with black organza or tulle. The small lighthouse details can be painted with fabric paint. After sewing the raw edges, trim and square the block to 6½" × 6½".

Washington (WA)

"The Evergreen State" was the 42nd state to enter the Union, admitted in 1889. West of the high Cascade Mountains, its temperatures are mild, with wet winters and dry summers. This western region has dense evergreen forests and areas of temperate rain forest. However, eastern Washington has a relatively dry climate and a few arid deserts. Mount Rainier, Washington's tallest peak, is a dormant volcano that last erupted in 1969. This mountain is less than an hour's drive from Seattle. Nearby Mount St. Helens last erupted in 1980. Apples are the state's main crop. The largest city in Washington is Seattle, with its many coffee shops and a notable skyline highlighted by the famous Space Needle, built for the 1962 World's Fair.

DIRECTIONS

Cut a 4½″ × 6¾″ rectangles for the sky (piece 1) and a 3½″ × 6¾″ rectangle for the land (piece 2). Leave excess to square and trim the block later. Sew the sky/land together with a ¼″ seam to make the background. Trace, cut, position, and fuse the remaining pieces in place. If included, the sunrays can be created with organza or tulle. The same organza or tulle will work well for the water ripples. After sewing the raw edges, trim and square the block to 6½″ × 6½″.

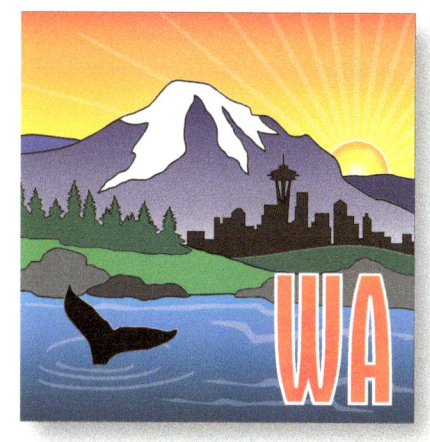

Washington

Patterns 65

West Virginia

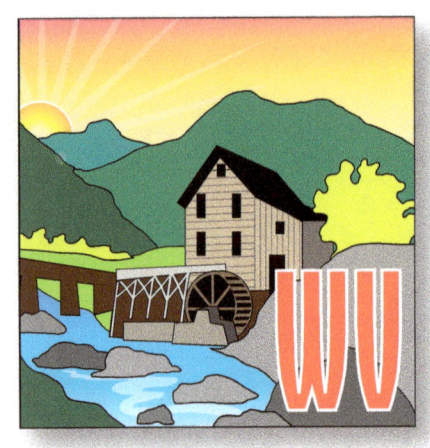

West Virginia (WV)

"The Mountain State" was the 35th state to enter the Union, admitted in 1863. West Virginia is located entirely within the Appalachian Mountain range and has an average elevation of 1,500 feet above sea level, the highest state average east of the Mississippi River. This mountainous state has a humid continental climate. Summers are quite warm, and winters are snowy and cold. The most photographed location in the state is Glade Creek Grist Mill at Babcock State Park in south central West Virginia. Built in 1976 from parts and pieces of three mills dating back to 1890, Glade Creek Grist Mill is a living, working monument that represents the more than 500 mills that used to be in service throughout the state.

DIRECTIONS

Cut a 4½˝ × 6¾˝ rectangle for the sky (piece 1) and a 3½˝ × 6¾˝ rectangle for the land (piece 2). Leave excess to square and trim the block later. Sew the sky/land together with a ¼˝ seam to make the background. Trace, cut, position, and fuse the remaining pieces in place. If included, the sunrays can be made with white organza or tulle. The small black slats on the water wheel can be created with fabric markers. After sewing the raw edges, trim and square the block to 6½˝ × 6½˝.

66 Quilt Blocks Across America

Wisconsin (WI)

"The Badger State" was the 30th state to enter the Union, admitted in 1848. The name Wisconsin is thought to come from French corruption of a Native American Algonquian word. The meaning of the word is disputed, but it is generally accepted to be "waters that meander through something red," referring to the Wisconsin River that flows through the reddish sandstone of the Wisconsin Dells. Summers in this Great Lakes state are warm and humid, while winters can be very cold with substantial snowfall. Wisconsin, also known as "America's Dairyland," produces more milk, cheese, and dairy products than any other state.

DIRECTIONS

Cut a 3½″ × 6¾″ rectangle for the sky (piece 1) and a 4½″ × 6¾″ rectangle for the land (piece 2). Leave excess to square and trim the block later. Sew the sky/land together with a ¼″ seam to make the background. Trace, cut, position, and fuse the remaining pieces in place. If included, the sunrays can be created with white organza or tulle. The shadows (pieces 10 and 19) can be created with black organza or tulle. The barn details can be fabric painted or embroidered. After sewing the raw edges, trim and square the block to 6½″ × 6½″.

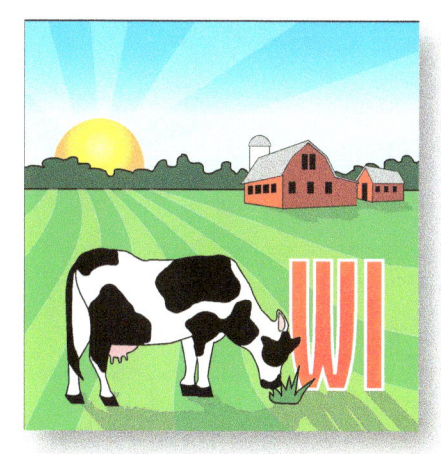

Patterns 67

Wyoming

Wyoming (WY)

"The Equality State" was the 44th state to enter the Union, admitted in 1890. Wyoming, meaning "large prairie place" in the Native American Algonquian language, is a landscape dominated by the Rocky Mountains in the west and the High Plains of the east. The state's weather is generally dry and windy, with a diverse temperature range. Wyoming's women were the first in the nation to vote, to serve on juries, and to hold public office. Wyoming has notable production of coal, natural gas, and crude oil. Yellowstone National Park boasts its famous cone geyser, Old Faithful, which spouts 200°F water up to 160 feet high roughly every 90 minutes. Wyoming is the tenth largest state, but the least populated in the United States.

DIRECTIONS

Cut a 4½˝ × 6¾˝ rectangle for the sky (piece 1) and a 3½˝ × 6¾˝ rectangle for the land (piece 2). Leave excess to square and trim the block later. Sew the sky/land together with a ¼˝ seam to make the background. Trace, cut, position, and fuse the remaining pieces in place. Old Faithful's mist (piece 8) and the sunrays (if included) can be made with white organza or tulle. After sewing the raw edges, trim and square the block to 6½˝ × 6½˝.

Quilt Blocks Across America

Alphabet Patterns

Note This is alphabet is available reversed on the CD.

Mount Rushmore (for SD) and Route 66 (for OK)

Dk Gray | Med Gray | Lt Gray | Gray | White

You can scan and print whole mountain onto fabric or use patterns below.

Whole Mt. for scanning

ROUTE 66

Rt. 66 for scanning

9* Washington

6* Lincoln

8* Jefferson

T. Roosevelt 7*

70

Dixon Family Escapades, full-size bed quilt, 84" × 84"
Linda R. Dixon

Oregon flag, 11" × 14"
Margaret Minton

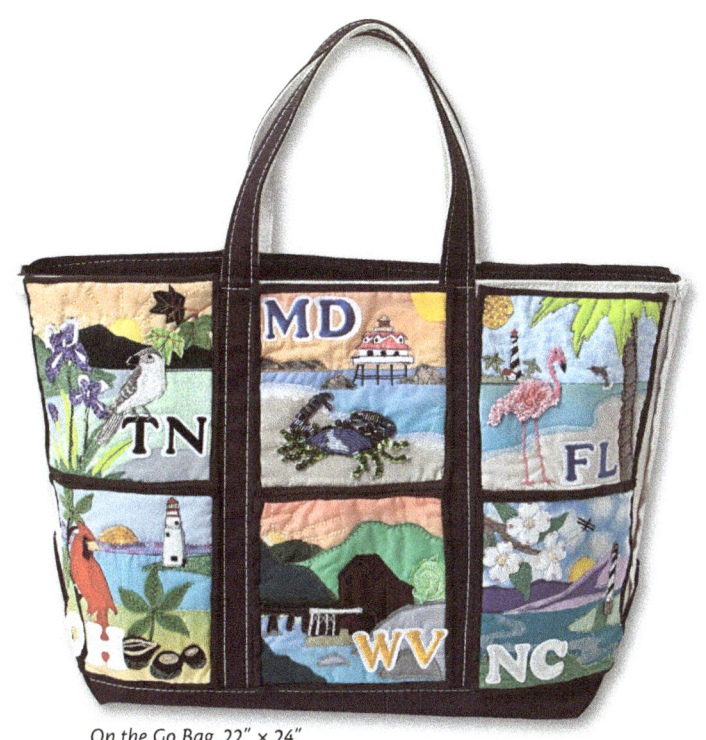

On the Go Bag, 22" × 24"
Monica H. Agapaloglou

Gallery

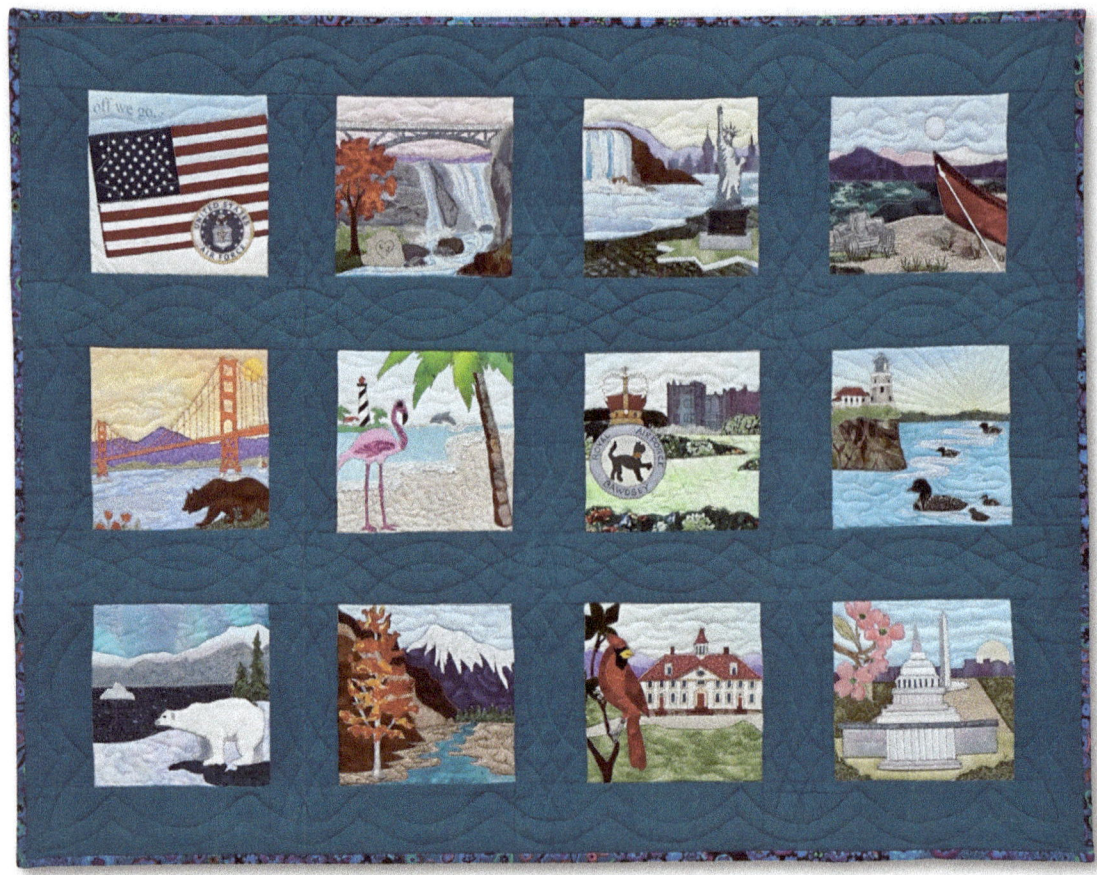

Off We Go—The Journey of Our Air Force Life, 36˝ × 30˝
Lee Zadareky

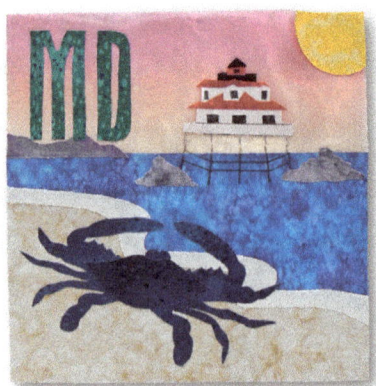

Maryland block, 12˝ × 12˝
Austin Gabel

Utah block, 12˝ × 12˝
Debra Gabel

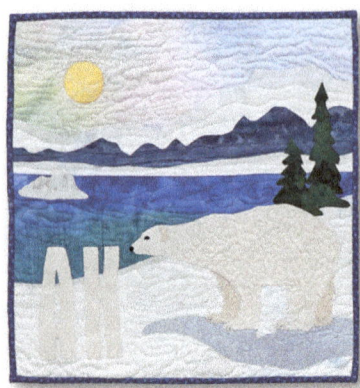

Alaska in Blue, 16˝ × 16˝
Linda K. Bernard

Vermont block, 12˝ × 12˝
Debra Gabel

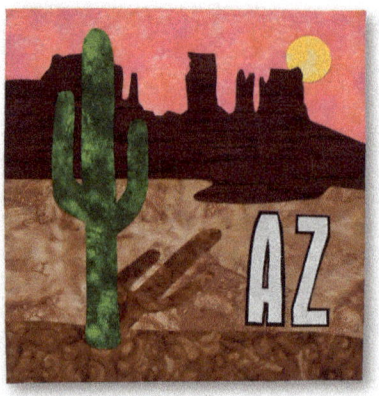

Arizona block, 12˝ × 12˝
Debra Gabel

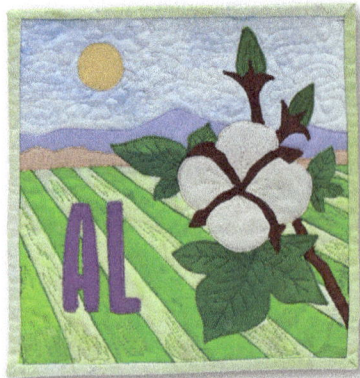

Alabama Fields, 8˝ × 8˝
Linda K. Bernard

Where I've Been, Part I, 30" × 30"
Stephanie Sanidas

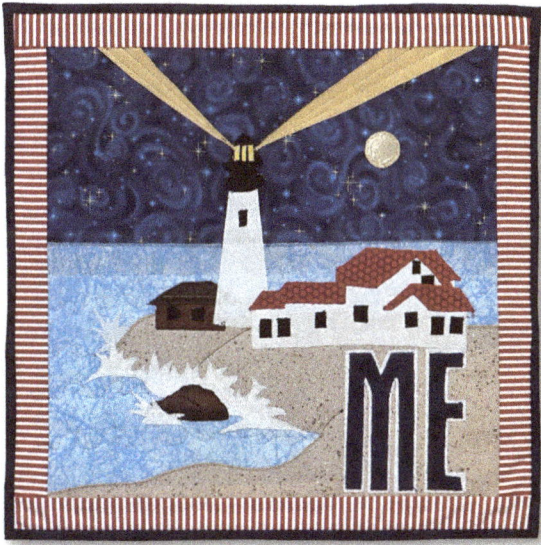

College Days in Maine, 16" × 16"
Patti Ogden

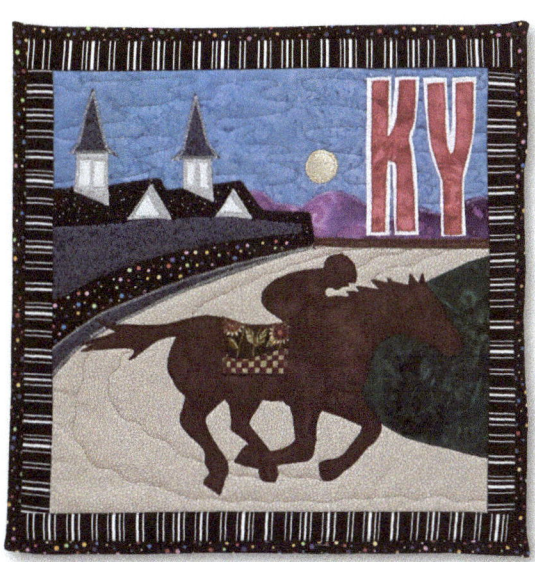

My Husband's College State, 16" × 16"
Patti Ogden

Gallery

Gallery

Cross Country Adventure, 56½" × 56½"
Patti Rusk

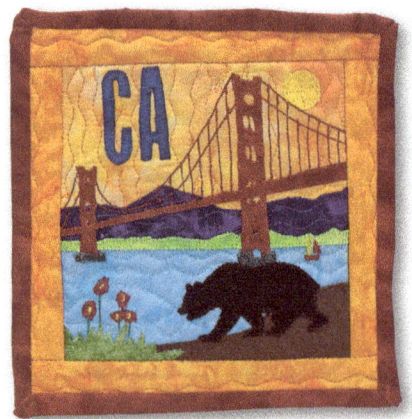

California block, 6" × 6"
Cynthia Porter

Colorado block, 6" × 6"
Cynthia Porter

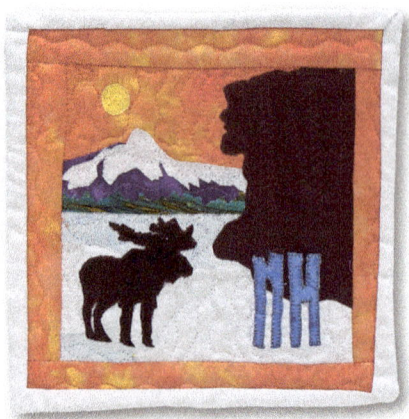

New Hampshire block, 6" × 6"
Cynthia Porter

Traveling Tanners, 70″ × 84″
Cathy Tanner Logan

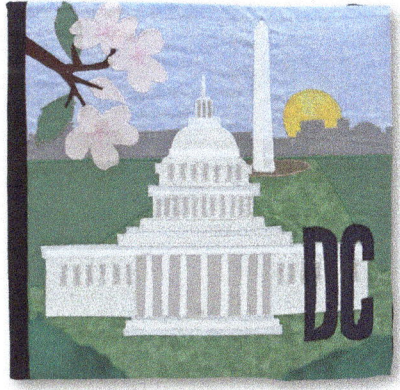

Washington, D.C., scrapbook album cover, 14″ × 14″, Amy Logan McPherson

New York in a frame, 12″ × 12″
Amy Logan McPherson

Nevada block, 20″ × 20″
Linda R. Dixon

Gallery

Where Bob's Lived, 42½" × 42½"
Genie Corbin

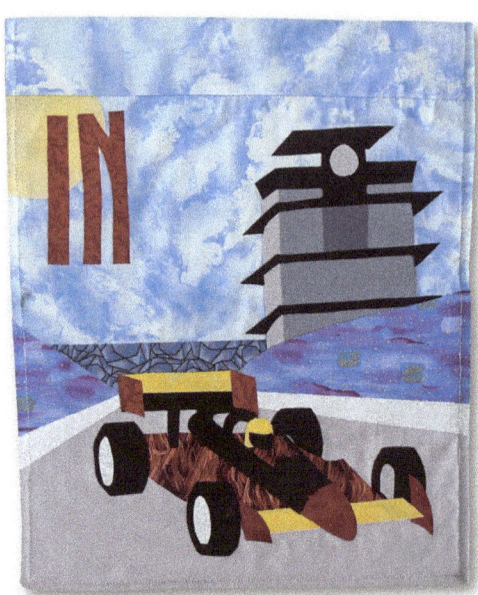

Indiana flag, 11" × 14"
Margaret Minton

Colorado wallhanging, 15" × 18"
Linda Bernard

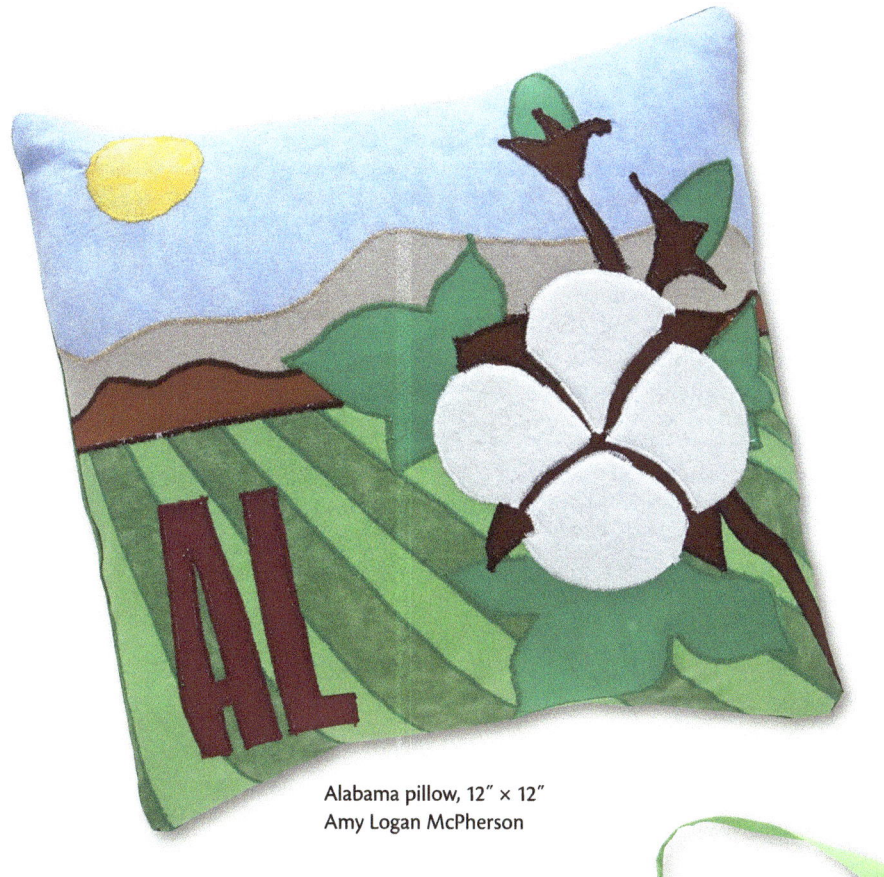

Alabama pillow, 12″ × 12″
Amy Logan McPherson

Placemat, 12″ × 12″
Amy Logan McPherson

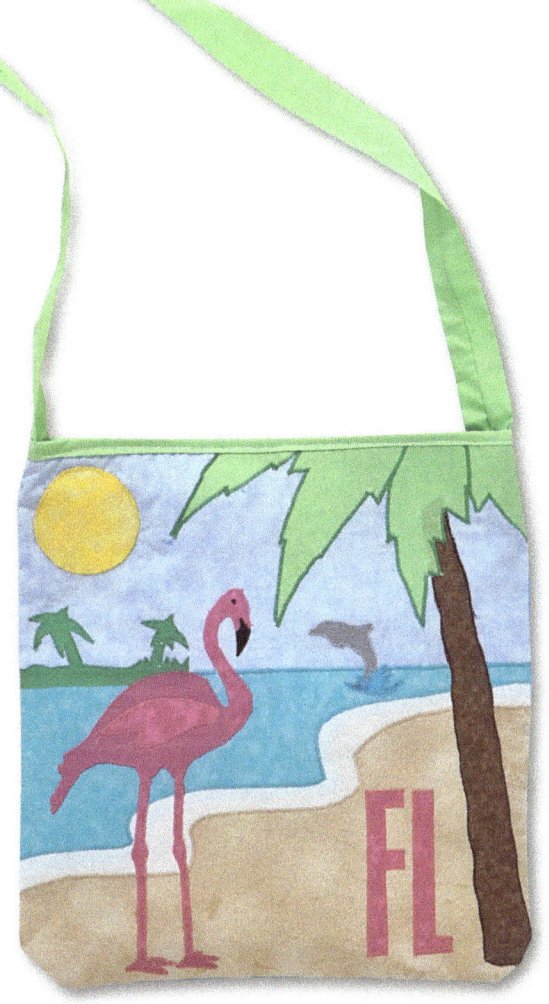

Florida tote bag, 12″ × 12″
Amy Logan McPherson

Supplies and Resources

Listed below are the manufacturers and sources of supplies and materials recommended throughout the book. These are for your information in the event you would like to try them out.

attached inc.
60 Washington Avenue
Brooklyn, NY 11205
631-750-8500
www.mistyfuse.com

Bear Thread Designs
P.O. Box 1452
Highland, TX 77562
281-462-0661
www.bearthreaddesigns.com

Hoffman California Fabrics
25792 Obrero Drive
Mission Viejo, CA 92691
800-547-0100
www.hoffmanfabrics.com

Kreinik
1708 Gihon Road
Parkersburg, WV 26102
800-537-2166
www.kreinik.com

The Warm Company
5529 186th Place SW
Lynwood, WA 98037
425-248-2424
www.warmcompany.com

WonderFil Threads
2915 19th Street NE, Bay 3
Calgary, AB T2E 7A2 Canada
403-250-8262
www.wonderfil.net

YLI
1439 Dave Lyle Boulevard, #16C
Rock Hill, SC 29730
803-985-3100
www.ylicorp.com

Zebra Patterns
13618 Meadow Glenn
Clarksville, MD 21029
410-531-9047
www.zebrapatterns.com

Glossary of Terms

appliqué Process of adding a cut piece of fabric on top of an underlying fabric

appliqué pressing sheet Nonstick translucent sheet used to protect ironing surfaces and irons from glues and/or fusing materials

basting Technique used to hold the finished top, batting, and backing fabric together before quilting. Basting is typically done with safety pins, longhand stitches with thread, or sometimes plastic tacks. This book uses a fusing technique that eliminates positioning many pins or stitches and fastener removal by using a commercial product called Mistyfuse.

batting Commercial product made to sandwich between your finished top and backing fabrics to provide loft and warmth

bobbin picking Undesired effect of bobbin thread showing on the top of the quilted project due to uneven tension

buttonhole stitch (Also known as *blanket stitch*) Stitch on the sewing machine that will finish raw edges. This stitch is characterized by a single straight running stitch followed by a perpendicular straight side stitch. This pattern repeats, creating a half ladder look. Buttonhole stitch often uses contrasting thread to show off the decorative stitch. It is most often used in traditional country and folk art projects.

finished block size Measurement the block will finish to when sewn together. Seam allowances are *not* added into this number.

fusible webbing Commercial heat-sensitive glue product in the form of a webbing that is made to adhere fabric to fabric

fusing Process of heating and melting fusible webbing to the back side of fabric in order to join two or more pieces of fabric and/or batting and fabric together without sewing

Mistyfuse Specialized, commercially available fusible webbing product without a paper backing. It is extremely lightweight, airy, and flexible and is used in this book for basting.

needle down position Position of the sewing machine needle when it is piercing through fabric. The position most used for pivoting (turning the work to change direction). Many new sewing machines have this as an automated feature. If you do not have this feature, you can simply hand turn the sewing wheel to position your needle in the fabric for pivoting during sewing.

open-toe foot Commercially available accessory for sewing machines. This sewing foot has a wide open area in front of the sewing needle, unlike a closed toe, which has a metal or clear plastic bar in front of the needle. The metal bar impedes your ability to see the raw edges of the fabric easily, while the clear bar can distort the positioning of the needle.

organza Sheer, lightweight, translucent fabric; recommended in this book for cloud, sunray, and shadow effects

printable fabric Commercial product; typically a piece of white fabric adhered to a removable backing; used in ink-jet printers to place graphics, drawings, and photos onto fabric

raw edge Edge of fabric when cut and left "raw" when the fabric is quilted; as opposed to "turned" fabric edges. The most common non-quilting example of a turned edge would be the hem of a pant leg. Raw edges in quilting can unravel if not properly fused and sewn.

rotary cutter Commercially available cutting blade in a plastic holder that makes cutting fabric, particularly straight lines, quick and accurate

satin stitch Dense zigzag stitch in which the zigs and the zags touch each other where they pierce the outer edges, creating a thick line appearance

seam allowance Typically in quilting, the seam allowance is ¼˝ of fabric added to the seam edge for machine sewing.

tear-away stabilizer Commercial product used to temporarily lie beneath the quilt or block top to make the fabric more stable and stiff. This is done to accommodate dense, raw-edge stitching without puckering the top. There are many types of stabilizers, including wash-away, tear-away, and leave-in. Tear-away stabilizers easily tear away, leaving stitches flat while removing excess stabilizer. Leaving stabilizers in fabric will make the project thicker and slightly rigid.

tracing patterns Process of placing translucent tracing paper over patterns and copying shape outlines with a pencil to make individual pattern pieces

Translucent Patterning Pattern method allowing the quilter to trace each piece *and* see color, positioning, and overlap all in one block

tulle Lightweight, netlike translucent fabric recommended in this book for cloud, sunray, and shadow effects

unfinished block size Measurement of the block with seam allowances added into the measurement

zigzag stitch Stitch that evenly and equidistantly moves from side to side. The stitch is adjustable in both width and length.

About the Author

Born in Middletown, New York, Debra started sewing as a child and quilting as a teen. After several professional moves around the United States in adulthood, she finally settled in Clarksville, Maryland, with her husband, Gary, and their three sons, Brooks, Austin, and Cole. Armed with a Bachelor of Fine Arts Degree in graphic design, Debra worked for many years as an art director in the packaging industry, where she designed and prepared art for paper-handled shopping bags, consumer goods, tissue, decorative boxes, and other packaging. Debra has also maintained her independent graphic design business, Mixed Media, since 1988.

After rediscovering quilting in the late 1990s, Debra started teaching quilting locally in 2000. Her classes were based on patterns she had designed for baby quilt gifts and a simple Christmas stocking pattern. The popularity of the classes and the interest in the patterns were the start of a small pattern line and additional part-time teaching opportunities.

In 2003 at age 42, Debra was shocked to be diagnosed with non-Hodgkin's lymphoma, late stage three. It was a trying time for the whole family. Rigorous chemotherapy began in August, concluded in November, and was followed by an autologous (self-donor) bone marrow stem cell transplant on December 26. Released from Baltimore's Johns Hopkins Hospital in January 2004 with a new lease on life, the slow process of an almost two-year recovery began.

It was a time of deep reflection. All of the time in and out of the hospital, with endless days spent in bed, losing friends and acquaintances met during treatments at Johns Hopkins, gave her ample time to review her life and think about what might be her future. Inspired by the words of Oprah Winfrey, she decided to *follow her passions*—quilting and design—and to shoot for the moon. The first goal during that recovery period was simple: to regain the basic independence of getting up and dressed by herself each day. Over time, the plan to give serious effort to being a pattern designer was firmly in place.

Debra started thinking about a name for her new pattern company. Being a graphic designer, Debra loves bold colors and black and white. She particularly likes black and white stripes. Since her name is Debra, she decided to drop the "D" and replace it with a "Z," and Zebra Patterns was born.

Since the first few patterns designed in the pre-cancer days, Debra has steadily built up her quilt pattern line to include 25 beautiful florals, 12 birds, 12 butterflies, 12 Bible stories, 13 signature stamps, several baby quilts, and many unique quilted projects and art quilts. Debra currently teaches and lectures at guilds and quilt shops in the United States, while regularly adding new patterns and products to the Zebra Patterns line.

Debra has also had success entering and showing her quilts in regional and national quilt shows; has had her quilts appear in calendars, quilt books, and websites; and has been featured in and authored magazine articles.

Debra's intentions are to continue lecturing, teaching, and evolving as a quilter, speaker, and author. She would like to travel the world through quilting. Debra has a website that showcases all of her art quilts, patterns, and an extensive ongoing blog called "Shoot for the Moon." Debra's blog tells the stories of her current activities—quilting and then some—and is a resource for quilters wanting to follow their passion with a pattern line of their own. Visit www.zebrapatterns.com for the blog and much, much more.

Great Titles *from* C&T PUBLISHING

Available at your local retailer or **www.ctpub.com** or **800-284-1114**

For a list of other fine books from C&T Publishing, visit our website to view our catalog online:

C&T PUBLISHING, INC.
P.O. Box 1456
Lafayette, CA 94549
800-284-1114

Email: ctinfo@ctpub.com
Website: www.ctpub.com

C&T Publishing's professional photography services are now available to the public. Visit us at www.ctmediaservices.com.

Tips and Techniques can be found at www.ctpub.com > Consumer Resources > Quiltmaking Basics: Tips & Techniques for Quiltmaking & More

For quilting supplies:

COTTON PATCH
1025 Brown Ave.
Lafayette, CA 94549
Store: 925-284-1177
Mail order: 925-283-7883

Email: CottonPa@aol.com
Website: www.quiltusa.com

Note: Fabrics used in the quilts shown may not be currently available, as fabric manufacturers keep most fabrics in print for only a short time.

www.ingramcontent.com/pod-product-compliance
Lightning Source LLC
Chambersburg PA
CBHW050940200526

45172CB00023B/1347